Kandinsky

Trap Street / Dinomania

Two Plays

Salamander Street

PLAYS

First published in 2020 by Salamander Street Ltd.
(info@salamanderstreet.com)

Trap Street & Dinomania © Kandinsky, 2020

PB ISBN: 9781913630102
E ISBN: 9781913630119

Printed and bound in Great Britain

10 9 8 7 6 5 4 3 2 1

For David Byrne and Poppy Keeling

Introduction

Whenever a play is published, there are certain assumptions we make about authorship – usually it's safe to assume that the writing and the ideas belong to one person, whose name is written on the spine. But we can say one thing for certain about the plays in this book: they were not written by Wassily Kandinsky[1], or by any other sole person.

We make our shows through a collaborative devising process that is fed into by every artist working on the production. We've been making shows like this since 2015 and it differs from a traditional scripted process in lots of ways, mainly that we don't have a play when we start rehearsals, so it's a particular kind of frightening for the performers. There are different stages to the process: reading and researching, gathering material, talking for hundreds of hours, then dragging things into rehearsal rooms with actors, musicians and designers to find out what kind of show we can make with the people we have in the room.

We're absurdly excited that these plays are being published, but when we came to finesse the scripts, things got strange and complex. Texts by a playwright might change in rehearsals, sometimes a lot, but the level of stage direction and description stay rooted in one person's vision. Our text is rooted in its original production, in the hard work and ideas of every single person in the rehearsal room; working out how best to represent texts that were made like this, how to make them intelligible and pleasurable to read, has not been straightforward.

The process required us to imagine a reader (you); to imagine why somebody would pick this book up. Will the texts be read by people planning their own productions? By people who want to remember ours? Or just by our Mums? To please everyone[2], we've tried to walk a line between clarity and not over-describing, and we hope anyone staging their own version of either show would feel relatively free with the scripts.

Both shows were made by and for a particular group of people, but we think there's potential to stage them with larger companies and in very different ways, and ultimately you should have fealty to the reality of whoever you have in the room with you. Our only request would be that you assemble a room full of people who represent the world around you, as it is now, over and above any naturalistic reality in the text. *Dinomania* is full of Victorian men with beards, but it's also got dogs and horses and babies and lions and duck-billed platypuses.

1 Painter, 1866–1944. People sometimes imply that it is cultured (pretentious?) of us to have a theatre company named after an artist and we would like to assure you that the company was in fact named after a cat (though the cat was named after the artist).

2 Especially our Mums.

You probably won't be casting any lions, so it's best not to get too hung up on the Victorian men either.

We began making theatre through a devising process in 2014 and *Trap Street* was the third show we made this way. It began as an idea about maps and mapmaking, but the more we read about London, and who owns it – how it's been bought and sold and changed hands, even land that appears to still belong to the public[3] – we began to realise it was a show about social housing. Everything we've made belongs to the people we made it with, but we're particularly grateful to all the members of the company and creative team who'd grown up in social housing and brought elements of their real lives into the rehearsal room with generosity and trust. The graphic novel *Here* by Richard McGuire, depicting a single room over millennia, was also a huge influence on the show, and is fantastic.

Dinomania was our fourth show, but the idea had been around for years: we'd wanted to make something about the discovery of dinosaurs since reading Deborah Cadbury's brilliant book, *The Dinosaur Hunters*, several years before. This, and Adrian Desmond's *The Politics of Evolution: Morphology, Medicine and Reform in Radical London*, were hugely useful, and we also got great additional reading from Dr Alice Marples – although inevitably there's some fudging of the facts in our version, with apologies to any keen historians. The original tooth that Gideon Mantell found is on display in the Natural History Museum, London, as well as a bust of its founder, Richard Owen, hidden round the corner at the top of the stairs. Both are well worth a visit.

We also have to mention the one thing we couldn't find a way to properly reflect in this book. Anyone who saw either of these shows will know that there's an intimate connection between every single thing that happens on stage and the music, which for both of these plays, as for several others, was composed and performed by Zac Gvirtzman, a uniquely talented and patient person. Zac is in the room with us for every rehearsal and the action of the play is both developed alongside and inextricably connected to his music. We have been incredibly lucky to work with him so often.

Finally, the hugest of thanks to everyone who worked on both these shows. They are yours. We hope you like your book.

3 *Ground Control* by Anna Minton is great on this, if you're interested.

CONTENTS

Trap Street

Trap Street was first performed on 6 March 2018 at New Diorama Theatre, London.

The cast was as follows:

Amelda Brown

Hamish MacDougall

Danusia Samal

Music composed and performed by Zac Gvirtzman

Directed by James Yeatman

Dramaturgy by Lauren Mooney

Production co-design by Joshua Gadsby and Naomi Kuyck-Cohen

Stage management by Eleanor Dear

The original production was developed and staged with support from Complicite, Unity Theatre Trust, the Foyle Foundation, the New Diorama Emerging Companies Fund and supported using public funding by the National Lottery through Arts Council England.

Trap Street was devised by the cast and creative team.

Note

This show could be staged with a company of any size.

We made it with three actors and a musician. The actors doubled as follows:

ONE Andrea
 Val

TWO Young Andrea (Y.Andrea)
 Esme
 Derek Sykes
 Donna
 Door-knocking women (Sally, Sheila, Sandra, Betty)

THREE Graham
 Town Planner
 Richard
 Pathe News Man
 Jeff
 Mr. Havering
 Trevor
 Door-knocking men (Man 1-5, Old Man, Little Boy)
 Jeremy
 BBC Man
 Newman the architect
 Guard
 Policeman

The action takes place on the Austen Estate, a post-war dream of the future, between 1962 and 2017.

Most of it is in the living room of the Welch family flat.

A TV screen displays the year in which each scene takes place.

TV: KEEP OFF THE GRASS

The **ACTOR** *who will play Young Andrea* (**Y.ANDREA**) *walks onstage.*

ACTOR: Good evening. We'd like to start tonight's show with an extract from 'Maps & Mapmaking' by Florence Shorrock:

(She reads.)

"People don't make new maps of cities much these days, but they used to. Lots of people made lots of maps, and lots of other people stole them.

Because they're factual information – maps – and you can't copyright what's true, there was nothing to stop people stealing from the cartographers, passing their hard work off as their own and selling it on.

So, to protect their livelihoods, map-makers set traps for wannabe thieves: minor geographical inaccuracies. Hills too high, rivers winding slightly wrong – and in the cities sometimes, streets that weren't really there.

Fake streets that, if they appeared elsewhere, would reveal the map's true provenance.

Cartographers called these 'Trap Streets'. They still turn up in maps of London today. There are about a hundred in the London A to Z.

These places that, according to the facts we have, exist, but also don't."

She stops reading.

We found this trap street on a London County Council map depicting bomb damage to the east of London in 1943. Everything you're about to see takes place there, on a street that doesn't exist.

TV: 1971

5

ACTOR *becomes* **Y.ANDREA.** *The* **TOWN PLANNER** *stands. He is in the audience.*

T.PLANNER:	Excuse me?
Y.ANDREA:	What?
T.PLANNER:	I wondered if you could tell me where the mere is?
Y.ANDREA:	The what?
T.PLANNER:	The mere. It's a large water feature. It's the sort of focal point of the… Essentially it's a place with lots of water in the middle and grass all around it, do you know anywhere like that?
Y.ANDREA:	Are you talking about the duck pond?
T.PLANNER:	Well, I wouldn't describe it as a duck pond. Listen, according to my map it's next to a block called Pemberley House…?
Y.ANDREA:	Yeah, that's where I live, and we call it the duck pond.
T.PLANNER:	Okay. Fine. Well can you tell me how to get there?
Y.ANDREA:	Why do you want to go there for, it stinks
T.PLANNER:	I'm on a work trip and I need to meet my friends there.
Y.ANDREA:	What sort of work do you do?
T.PLANNER:	We make buildings. Big buildings.
Y.ANDREA:	Are you an architect?
T.PLANNER:	Not quite.
Y.ANDREA:	Town planner?
T.PLANNER:	Oh. Very good.
Y.ANDREA:	Yeah we get loads of them round here. Two months ago one of them went missing.
T.PLANNER:	What? Who? Why am I asking you this
	Look, can you just tell me where the water is please?

Y.ANDREA:	All right, there's two ways to get there. Do you want the long way or the short way?
T.PLANNER:	Let's go for the short one.
Y.ANDREA:	All right. You see that archway down there?
T.PLANNER:	Yes
Y.ANDREA:	Right. Go through that, you'll see a block of flats on your left, Kellynch House, now this won't feel like a shortcut but it is. Go up two flights of stairs. Two, not three
T.PLANNER:	Got you
Y.ANDREA:	Yeah three will take you to the car park that no one uses. So you go up two flights, and be careful as you pass Mr Fletcher's because he's got a massive dog and he never ties it up
T.PLANNER:	Okay, I'll avoid the dog
Y.ANDREA:	Good. And you'll see a big red door – go through that and you're on a bridge. Cross it, but be careful as sometimes people wee round there. And then you'll see a park, I mean it's not really a park, it's just mud, but it's meant to be a park
T.PLANNER:	Ah, yes, Ladbrokes.

TV: Ladbrokes

*From now on, the TV changes to whatever **T.PLANNER** says.*

Y.ANDREA:	No –
	The bridge takes you to another block, Darcy House. Which has only got one stairwell and they close that after three but you can cut through, you'll be in a little alleyway, but just keep going on because eventually it becomes a –
T.PLANNER:	A Jobcentre.

Present-day **ANDREA** *is there.*

Y.ANDREA: *(Confused.)* No. There's a building that's meant to be a shop but it's not a shop yet

T.PLANNER: Wimpys.

Y.ANDREA: No. By the toilets, the public toilets

ANDREA: I never used them, they stank.

Y.ANDREA: Past the library

T.PLANNER: The Ideas Store.

Y.ANDREA: No, next to the maisonettes

T.PLANNER: Le Pain Quotidien.

Y.ANDREA: With garages and a little garden

ANDREA: Where my first boyfriend lived.

Y.ANDREA: Past that, there's a low wall

ANDREA: With signs saying keep off the grass.

T.PLANNER: Smile, you're on CCTV.

Y.ANDREA: Jump over the wall

ANDREA: But as long as you were playing quietly and

T.PLANNER: See it. Say it. Sorted.

ANDREA: weren't playing ball games, they used to let you.

T.PLANNER: Fitness First.

Y.ANDREA: And turn left at the pub

ANDREA: The Admiral Nelson.

T.PLANNER: Craft ale.

ANDREA: And there used to be a separate off license in there where you could buy

T.PLANNER: Sourdough.

ANDREA:	Chocolates.
T.PLANNER:	Smashed Avacado.
Y.ANDREA:	*(Neutral, almost a Sat Nav.)* Continue for thirty yards.
ANDREA:	Crisps! Crisps that had a little blue packet with salt in.
T.PLANNER:	Rice Cakes.
ANDREA:	You would open it up and shake the salt in yourself
T.PLANNER:	Gluten free bakery.
Y.ANDREA:	Turn right at
ANDREA:	Abbots! They sold groceries and cut meats
T.PLANNER:	Tesco Metro.
Y.ANDREA:	Continue on Bennett Avenue.
ANDREA:	Ham, spam and cheese and things.
T.PLANNER:	Bottomless Prosecco.
Y.ANDREA:	Bear left at Collins Bridge

*The past and present are contained now in **ANDREA**'s speech. The modern, bolded words interrupt the flow of her thoughts. When she reaches them, they appear on the TV screen.*

ANDREA:	Graham spat on me from up there. Didn't his mate piss on someone? Kevin. Dear delicate Graham, such a nice boy, wouldn't have a word said against him. "lay the table Andrea!" "Can't Graham do it?" "Graham's feeling poorly." **LONDON'S NEW TOWN** Always the favourite, had to be protected, uniform spick n span, ironed by me, though wasn't, couldn't do it himself. **HELP TO BUY** Pinching my leg under the kitchen table, bruises all down my thigh, and I was the one told off for making a fuss **FOXTONS** Bloody sly bugger. When Mum did spot checks of the bedroom, where did she find his fags? Under my bed! **CONSIDERATE CONSTRUCTION** Mummy's sweetheart, nicking a fiver from her purse, dirty magazines at the back of

the wardrobe, but no the sun shone out of his fucking, **STUNNING NEW APARTMENTS** Told her it weren't me that broke nan's china, it was him. Always forgiven, prodigal son, even when he brought home that bitch, looking down her nose like we were shit on her **SHARED OWNERSHIP** Telling me I gotta care about the Africans or the fucking Chileans **IF YOU LIVED HERE YOU'D BE HOME BY NOW** But when it came to his own mother, the woman who scrimped and saved to get him where he is, **TO LET** the woman who is dying, what is it? **FOR SALE** A bloody bouquet from M&S, and she wouldn't shut up about that for months, even though it was me wiping her arse **FOR SALE** Not a penny for the funeral, guess they spent it all on that lovely house in Hampstead, **FOR SALE** or the holidays in the South of France, **FOR SALE** or the school fees **FOR SALE** or the wine cellar **FOR SALE** but there he was, head mourner, "so sorry for your loss Graham" **FOR SALE** "Yeah she was a wonderful woman, they don't make 'em like my Mum anymore, she was a one-off. A diamond." **FOR SALE, FOR SALE, FOR SALE**

FUCK.

TV: JANUARY 2017

ANDREA's at the stairwell door of Pemberley House.

It's locked.

She can't get in.

She tries again.

Fails.

Gets out her phone. Dials.

ANDREA: Hello Jeff, it's Andrea. Yeah so I'm outside the flat but I can't get in. It's a different key to the stairwell. Well it's not a key it's a… Think you should have told me actually. Can you call me back? Urgent.

She buzzes a flat. No answer. Waits, then does it again. Still no answer.

She's pissed off. She presses again, hard, calling lots of flats at random – until **RICHARD***'s voice answers. There is music in the background.*

RICHARD: *(Off.)* Hello?

ANDREA: Hello!

RICHARD: *(Off.)* Er, hello?

ANDREA: Oh hi I'm locked out

RICHARD: *(Off.)* Wait one second please –

ANDREA: *(Thinking he's about to hang up.)* No no no no

He turns the music off.

RICHARD: *(Off.)* Hello?

ANDREA: Yeah – hi, sorry, I'm locked out. Can you buzz me in please?

RICHARD: *(Off.)* You're locked out?

ANDREA: Yeah

RICHARD: *(Off.)* Um. Right, okay, sorry, what flat do you live in?

ANDREA: 362

RICHARD: *(Off.)* 362? Right. Are you a guardian

ANDREA: I don't know what that means

RICHARD: *(Off.)* Okay. Look, sorry, we're not allowed to buzz anyone in.

He hangs up. **ANDREA** *yells in frustration then holds his buzzer down with her thumb.*

RICHARD: *(Off.)* Can you stop that please?

She keeps doing it.

 Can you

 Can you just

Okay right I'm gonna come down there, just please stop it.

She stops buzzing. She waits. **RICHARD** *opens the door.*

Look I'm really sorry but I can't

ANDREA: It's freezing out here, do you know that?

RICHARD: I'm / trying to explain

ANDREA: I need to get in to my flat.

RICHARD: Your flat?

ANDREA: Yes. 362

RICHARD: And you don't have a fob?

ANDREA: A fob?

RICHARD: You know, like a thing

ANDREA: No no. I have a key – see this? – for the stairwell, but clearly the system's been changed.

RICHARD: I think you need to call Donna. She's the manager

ANDREA: I don't know Donna

RICHARD: I can give you her number

ANDREA: I need to get in. Now

RICHARD: I'm not / allowed to

ANDREA: I have been travelling all day

RICHARD: I understand / I'm just

ANDREA: It's my flat

RICHARD: Unnnnngggg

ANDREA: What's your name?

RICHARD: Richard.

ANDREA:	Listen. Richard. I am desperate for a pee. So unless you want to see me piss in the street
RICHARD:	No, of course I don't want to see that
ANDREA:	Right.
RICHARD:	I shouldn't do this. Look, just come in all right?

He lets her in.

ANDREA:	Jesus. It stinks.
RICHARD:	Look, you really need to talk to Donna, okay? She's the manager of the – *(Stopping her.)* No, you can't use the lift
ANDREA:	Why not?
RICHARD:	You can't use any of the lifts okay, they've turned the power off. No one's really living here, it's just guardians now, property guardians.
ANDREA:	Right.
RICHARD:	I can take a bag if you like?
ANDREA:	Thanks Richard, you're a gent.
RICHARD:	I'm sorry, it's just Donna's really strict. I can show you a short way –
ANDREA:	I'll be fine
RICHARD:	Right – well listen, I'm – I live on the third floor if you ever – need me?

ANDREA *goes off.*

Music starts: Hello Stranger – Barbara Lewis.

TV: PATHE NEWS

PATHE:	The Thames. The soul of London.
	In the last 1000 years, this city has expanded along its banks, absorbing villages and towns – but here, on its eastern reach, on a once undesirable scrubland, lies

the future of London. A new way of living, for 3000 families. The Austen Estate.

PATHE NEWS MAN *leads us on a journey through the Estate that shows off its modernist grandeur and ambition.*

At the end of the war, a call rose up from the people: yes, the war was a tragedy, but what if it was an opportunity for London?

Did we need slums? Did we need poverty? Didn't the people deserve a clean, warm, modern place to call home?

Well – here in London, some of Britain's finest architects answered that call. The Austen will make those dreams a reality.

Yes, residents will enjoy all mod cons here: every family will have hot and cold running water, indoor lavatories, and even central heating – no more chilly mornings for these residents.

And in the summer, they can relax on their balconies in a deckchair – or bring the summer inside thanks to these cleverly designed sliding doors.

Rising out of the marsh like an ocean liner – or, on a wash day, like a ship in full sail – the Austen will be a place like no other. Yes, these lucky residents will have an estate fit for the 21st century – right here in 1962.

TV: 1962

We're in the flat. **ANDREA** *stands at the entrance.*

TV: 1972

ANDREA *stands at the entrance.*

TV: 1984

ANDREA *stands at the entrance.*

TV: 2017

ANDREA *walks into the flat. She puts her suitcase down.*

TV: 1963

Y.ANDREA *and* **GRAHAM**.

GRAHAM *has a broom. He shoots* **Y.ANDREA** *with it like it's a gun. They are kids.*

Y.ANDREA: Graham have you seen the pond

He shoots.

 Graham have you seen upstairs

GRAHAM: You've gotta die

Y.ANDREA: Eurggh. Graham. Did you see uptstairs

GRAHAM: Now you've got to shoot me

Y.ANDREA: Bang bang!

He dies.

 Graham have you seen the bedrooms, the beds are bouncy

GRAHAM: What bedroom

Y.ANDREA: The one at the back

GRAHAM: What my bedroom?

Y.ANDREA: *(Shocked.)* No.

GRAHAM: Yeah

Y.ANDREA: No – Mum said we could toss a coin

GRAHAM: No, Mum said I had the big the bedroom

Y.ANDREA: No, Mum said it would be fair for once

GRAHAM: No Andrea, Mum said I'd have the big bedroom 1) cos / I'm older

Y.ANDREA: You always say that

GRAHAM: And 2) cos I am bigger

Y.ANDREA: But I'm gonna get bigger too

GRAHAM:	No. You won't. 1) Cos you stink, and 2) cos you're a midget
Y.ANDREA:	Stop it. Stop it
GRAHAM:	My name's Andrea and I'm a smelly midget
Y.ANDREA:	Don't you'll give me nightmares
GRAHAM:	Midget midget
Y.ANDREA:	Mum. Mum. Graham's doing the midget thing

VAL enters.

VAL:	Andrea, where's your bow?
Y.ANDREA:	Mum who's gonna get the big bedroom
GRAHAM:	Just doing the sweeping / Mum
VAL:	Andrea. Where is your bow?
Y.ANDREA:	Mum, tell Graham you said we could toss a coin
VAL:	Come here.
GRAHAM:	*(Under his breath.)* Come here, midget.
Y.ANDREA:	Mum, tell him.
VAL:	What will they think of you? *(She ties the bow.)*
GRAHAM:	Yeah, Andrea
Y.ANDREA:	*(To GRAHAM.)* Shut up.
VAL:	Andrea, watch your mouth.
Y.ANDREA:	*(To VAL.)* You promised.
VAL:	I will not have this today.
Y.ANDREA:	Mum, please tell Graham about / the bedroom
GRAHAM:	Andrea stop going on about it
Y.ANDREA:	Ow

VAL:	Stop making a fuss.
Y.ANDREA:	You're hurting me
VAL:	Andrea.
Y.ANDREA:	I don't care about the bloody bow. You promised me it would be fair and now you're lying.

Beat.

VAL:	Graham. Take your bags to the big bedroom.
Y.ANDREA:	What?
GRAHAM:	*(Leaving.)* Thanks Mum!
VAL:	I'll not have an argument –
Y.ANDREA:	But –

TV: 1967

VAL:	You can't be like this anymore Andrea.
Y.ANDREA:	Mum

TV: 1972

VAL:	Not here.

TV: 1968

MALE VOICE:	*(From off.)* Hello? Andrea? Andrea?
VAL:	Don't.

Y.ANDREA *smirks, goes off.*

TV: January 2017

VAL *becomes* **ANDREA**. *She is alone. The man is still calling from off –*

JEFF:	Andrea?

He enters.

	Oh, Andrea. How are you? Nice to see you. How was Spain?
ANDREA:	Spain was lovely and warm, and nothing like here.
JEFF:	Right, well – that sounds lovely.
	Listen I've got your fob. I'm really busy today, so
ANDREA:	No, no, no. What's been going on here?
JEFF:	What do you mean?
ANDREA:	You said it was a family

We see that the flat is filthy.

JEFF:	*(Not surprised.)* Oh my God, look at that.
ANDREA:	Five mattresses to a room –
JEFF:	Andrea, look
ANDREA:	That is not a family.
JEFF:	Look, I rang them, yeah? I said you got to clean the place up, you gotta tidy, they obviously didn't listen to me
ANDREA:	A family. That is what we said. That's what we agreed
JEFF:	Look, Andrea, you got your money, you got what you wanted, so let's call it a day.
ANDREA:	I'll have the police on you.
JEFF:	What?
ANDREA:	This is criminal.
JEFF:	Criminal? Hang on, wait, you're going to call the police and you're gonna say what? Because technically I'm nothing to do with this. You're the one living here, it's your name on the rent book
ANDREA:	You said it was a family
JEFF:	Andrea, what family wants to live here? I did what you wanted. I've sorted it all out for you, I made it look like

	you were living here, like you hadn't been in Spain. So now you can go to the council, you can get your money and they knock the building down.
ANDREA:	How much were you charging the poor buggers?
JEFF:	The rate we agreed, and I gave you all your money minus my commission –
ANDREA:	How am I expected to live here?
JEFF:	Okay, look, I'll tell you what I can do – I can call some guys, they can come round, they can clean the place up. Does that sound okay? Look – here's your fob.
	Fine, I'll leave it in here, but don't lose this okay? It's the only one they'd give me.

He leaves.

ANDREA *begins collecting up rubbish. She picks up an old newspaper, unfolds it and kneels down on it to clean the floor.*

TV: 1962

We're in slum housing. Pre-Austen Estate.

Music – Stranger on the Shore by Acker Bilk

ANDREA *has become* **VAL**. *She is cleaning.*

HAVERING :	Mrs Welch?
VAL:	That's me.
HAVERING:	Hello – I'm Mr Havering from the LCC.
VAL:	Oh yes, I was expecting you.
HAVERING:	So I'm just going to do a tour of your property today if that's okay.
VAL:	Would you like to start in the kitchen?
HAVERING:	Why not.
VAL:	Here we are. Cup of tea?

HAVERING:	No thank you. Can I just clarify your occupation, Mrs Welch?
VAL:	Oh yes. I work in the planning department at the LCC. For Mr Burton, if you know / him
HAVERING:	Can I have a look in your cupboards?
VAL:	*(Taken aback.)* Yes –
HAVERING:	Thank you.
VAL:	Oh. It's impossible to get rid of the mould, I'm sorry.
HAVERING:	I do understand. And how long have you been here?
VAL:	Two years.
HAVERING:	Two years.
VAL:	Yes – before that we were in Monarch Buildings, but they were condemned. And clearly this place – it's not a permanent –
HAVERING:	And it's you and – ?
VAL:	The children.
HAVERING:	The children, right. And that's two children
VAL:	Yes. Graham and Andrea. Graham had diptheria shortly after we moved / here
HAVERING:	And Mr Welch doesn't live here?
VAL:	No.
HAVERING:	Right. Okay. Can we move on to the next room?
VAL:	Yes. Well. This is the children's room. As I was saying, Graham had diptheria, and it's / still on his
HAVERING:	How old are they?
VAL:	Graham is nine and Andrea's seven. It's / still on his throat and chest
HAVERING:	And where do they go to school?

VAL:	St Saviour's. It's left him very delicate
HAVERING:	And they've been there since?
VAL:	Since they were four.
HAVERING:	Right. Your room?
VAL:	In here. I do apologise for the clutter. We put everything in here / so the children would have
HAVERING:	We?
VAL:	I.
HAVERING:	It's only your name on the rent book?
VAL:	Yes that's right.
HAVERING:	And Mr Welch doesn't contribute / anything towards the –
VAL:	No.

Beat.

HAVERING:	Is that your cigarette?
VAL:	Yes. Yes. Just one or two a week, to steady my nerves
HAVERING:	Can I have a look in your wardrobe?

She doesn't want him to.

VAL:	Feel free. Oh, the basket's just got laundry in it –
HAVERING:	Thank you. That's all I need to see. So – you should receive a letter from us within the month.
VAL:	Could it not be any sooner?
HAVERING:	That's how long it takes.
VAL:	And may we be hopeful? About the Austen Estate? Mr Burton was very –
HAVERING:	As I said. You'll receive a letter.

21

TV: 1966

VAL's still cleaning, but we're in the flat on the Austen. She's made it.

Y.ANDREA walks in in her grammar school blazer.

VAL:	Look at you! Don't you look grown up?
Y.ANDREA:	I like it.
VAL:	Do you? That's good.
Y.ANDREA:	It's nicer than Graham's.
VAL:	Yes, I think it might be
Y.ANDREA:	Is it a bit big?
VAL:	Well, I suppose I could put a few tucks in. Here and – here. But you are gonna get bigger girl.

She hugs her for too long.

Y.ANDREA:	Mum?
VAL:	What?
Y.ANDREA:	Do you think they'll like me?
VAL:	Of course they'll like you
Y.ANDREA:	But I won't know anyone
VAL:	Graham's made lots of new friends
Y.ANDREA:	Are you sure?
VAL:	Andrea. Andrea. I am so proud of you. Let's go and get your brother. *(Running to get him.)* Graham! Graham!

Y.ANDREA is left alone in the room, in her blazer –

TV: 1967

– which fits her now. She pulls a bag of sweets from the pocket and looks at it.

ANDREA:	Finally, a person. A real person.

TV: 1967/2017

*ANDREA is on the phone in the kitchen, but may also be **VAL**, also on the phone.*

Y.ANDREA, in the living room, lays her sweets out on the floor

ANDREA:	Can you tell me your name?
	Right. Stacey. So – the offer.
	Yeah, I've got it here, do you want the reference?
	Oh, you've got it. Brilliant. Well you're still offering me 180 thousand and I'm calling to tell you I'm still saying no.

*In 1967, **GRAHAM** enters.*

Well I don't know how savvy you are on the property market Stacey –

*GRAHAM takes Y.ANDREA's sweets. Eats some. She calls out his name but he shushes her, points to the kitchen where **VAL** is on the phone.*

but what's 180 grand gonna get me round here?

Y.ANDREA chases him. They wrestle silently throughout the following.

No I'm not being patronising.

No I'm not Stacey. I'm just making it clear it's not like for like.

Just because you've screwed other people doesn't mean I'm gonna let you do it to me, what's the criteria? Tell me the criteria.

No, because, no you can't –

No, because you can't get a bloody shed round here for 180 grand–

I will not apologise for my language

I don't want to live in – I want to live here.

Y.ANDREA *has gone out and come back with one of* **GRAHAM**'s *porn mags. A silent threat to tell Mum. The tables have turned.*

> No Stacey you listen to me. My family was the original family on this estate. Yes. The Welches. We were on the telly. My mum, Stacey, practically built this place. Died here. And now you want to kick me out just so some bloody millionaire can have a place to put his mistress.

GRAHAM, *grovelling, returns the sweets and runs off with his porno.* **Y.ANDREA** *counts her losses.*

> How dare you? I haven't lived in Spain for four years. It's mine. And I want what it's worth.
>
> And I tell you what Stacey. I'm not leaving till I get it.

She hangs up.

TV: 1967

VAL *enters.*

VAL: Right, put your shoes on. *(Seeing the wrappers.)* What's this?

Y.ANDREA: Graham did it.

VAL: You're not allowed sweets before tea.

Y.ANDREA: But Emily gave them to me. They're from France

VAL: What?

(Taking the sweets.) France?

Y.ANDREA: They go there every year on holiday and she brought me these back as a present. Graham pinched loads of them, but…

A moment. **VAL** *smells the exotic sweets. She touches* **Y.ANDREA**'s *hair.*

VAL: That's very kind of Emily. But we don't have sweets before tea.

24

Y.ANDREA:	Can I take them with me? I won't eat any, I'll just hold them. I promise.
VAL:	Oh go on.
Y.ANDREA:	Is Graham coming with us?
VAL:	It's too cold for his chest.

The estate grows around them. The closer the following is to a big number, the better.

	But today you're gonna do some on your own all right?
Y.ANDREA:	All right.
VAL:	Do you want to knock on the first one? Go on.

Y.ANDREA knocks on a neighbour's door.

TV: 1963

TREVOR answers.

TREVOR:	Hello?
VAL:	Oh hello, I'm Mrs Welch – Valerie. Welcome to the Austen Estate.
TREVOR:	Thanks.
VAL:	And your name is…?
TREVOR:	Oh, sorry, I'm Trevor
VAL:	Wonderful to meet you Trevor. This is my daughter Andrea.
TREVOR:	Hello Andrea
Y.ANDREA:	Hello
VAL:	We just came by to see how you're settling in
TREVOR:	Oh yeah, very good thanks, my wife's over the moon
VAL:	A family man! Well if you need anything, want anything –

TREVOR:	Oh no, we're fine thanks.
VAL:	No we're happy to help. Andrea here's a very willing assistant
TREVOR:	That's very kind, but no, honestly,
VAL:	And I don't want to put too much on your plate
TREVOR:	Right
VAL:	but we're working with all the new arrivals to form a Residents' Association
TREVOR:	Oh right?
VAL:	Because – as the first families, Trevor – I think we have a responsibility, don't you? To build the new community.

Y.ANDREA *knocks on the next door.*

TV: 1964

VAL *turns, continuing to speak to the next person.*

VAL:	Because I think we have a responsibility, don't you? To build the new community.
MAN 1:	Right
VAL:	Exactly. So we're going to have fortnightly meetings. Over tea, you know, biscuits, at the community hall – 7pm sharp.
MAN 1:	Brilliant

Y.ANDREA *knocks on the next door.*

TV: 1965

VAL:	I'll chair. I work with the council, so I thought we could organise – fundraising, activities for the kids – a playground, trips, that kind of thing
MAN 2:	Sounds lovely

Y.ANDREA *knocks on the next door.*

TV: 1966

VAL: And then there's things with the flats – general maintenance, teething problems, communal gardens – hanging baskets…

MAN 3: Tell you what, that's a great idea. Because back in Bermondsey, I had an allotment.

VAL: Oh really?

Y.ANDREA *knocks on the next door.*

TV: 1967

VAL: And then there's day to day help, especially for the elderly: doing the shopping or just spending time – we thought we could have garden parties, cake sales

MAN 4: Cake? What kind of cake?

VAL: Er. Victoria / Sponge?

MAN 4: What's she eating?

VAL: Andrea!

They're sweets. From France.

MAN 4: Oh yeah?

VAL: From her friend at the grammar school.

MAN 4: They nice?

VAL: Andrea –

Y.ANDREA *has to give* **MAN 4** *a sweet.*

MAN 4: Not bad. Could I have another one?

Y.ANDREA *knocks on the next door.*

VAL: Hello?

OLD MAN: What

VAL: Hello

OLD MAN:	What
VAL:	Are you alright?
OLD MAN:	What
VAL:	We were wondering if we could help
OLD MAN:	What
VAL:	We wondered if….

OLD MAN *opens the door.*

VAL:	Hello. I'm Mrs Welch. From the Residents' Association. And this is my daughter Andrea. And she'd like to give you a sweet, from France, from her friend at the grammar school.
OLD MAN:	Well that's very kind.

VAL *knocks on the next door.*

Y.ANDREA:	I'm Andrea Welch my mum's formed the resident's association and we're talking to everyone who's new, we have lots of fun activities and at Christmas we raise money for the needy
MAN 5:	Oh, that sounds wonderful
Y.ANDREA:	We're building a new playground
MAN 5:	Where do I sign up?
Y.ANDREA:	And a crèche
MAN 5:	Great
Y.ANDREA:	And we meet on Thursdays at 7pm sharp.

Beat.

VAL:	Offer the gentleman a sweet Andrea. They're from France, from her friend at the grammar school.
Y.ANDREA:	
MAN 5:	A sweet, very kind. I'll see you on Thursday

VAL *knocks on the next door.*

Y. ANDREA: I'm Andrea Welch my mum's formed the resident's association at Christmas we raise money for the needy

MAN 6: I think I got that?

VAL: Give the gentleman a sweet Andrea. They're from France from her friend at the Grammar School.

MAN 6: Oh thanks.

 VAL *knocks.*

Y. ANDREA: I'm Andrea Welsh, d'you wanna come on Thursdays at 7pm?

MAN 7: …Yeah?

VAL: Sweets from France, friend at the grammar school

MAN 7: Tell you what, I'll take some for the kids. *(He takes a handful.)* Kids!

 VAL *knocks.*

Y. ANDREA: I'm Andrea Welsh, the Residents' Association, 7pm sharp

VAL: France, sweets, grammar school

MAN 8: Oh don't mind if I do

 VAL *knocks.*

Y. ANDREA: I'm Andrea Welsh, the Residents' Association

LITTLE BOY: I don't know.

Y. ANDREA: *(Annoyed.)* The Residents' Association

VAL: Andrea!

 (To the **BOY.***)* Is there a grownup indoors?

LITTLE BOY: No.

VAL: Mummy, or Daddy?

LITTLE BOY:	No.
VAL:	When will they be back?
LITTLE BOY:	I don't know

Y.ANDREA is admiring her remaining sweets.

VAL:	Are you all on your own?
LITTLE BOY:	
VAL:	Awww. Andrea. Why don't we give the little fella a sweetie, eh?
Y.ANDREA:	Mum!
VAL:	Andrea.

*Y.ANDREA offers the bag The **LITTLE BOY** looks at it.*

	Go on, you can take one.
LITTLE BOY:	Thanks
VAL:	Oh, give him the bag, let him have what he wants
Y.ANDREA:	Mum!
VAL:	Andrea
Y.ANDREA:	They're my present from Emily
VAL:	Andrea.

*A beat. **Y.ANDREA** shoves the sweets at him and storms off.*

TV: February 2017

The Experience Suite

Music: Ibiza House Chillout.

ANDREA *and* **JEREMY**.

JEREMY:	Hi. How are you doing today?
ANDREA:	I was just… having a look.

JEREMY:	Yeah, great. Look, if you've got any questions or need any help, I'm right here. Do you want a chocolate?
ANDREA:	Er, no thanks.
JEREMY:	Sure. Or a coffee? Tea? I've got all the teas
ANDREA:	No, I'm fine.
JEREMY:	Okay.

ANDREA wanders to front of stage. She lifts her hand to a touch screen.

JEREMY:	Ah – this is our digital guide. So actually the easiest way to use it: if you just swipe your hand across, it changes the image. Give it a go.

She swipes a couple of times.

ANDREA:	What's this?
JEREMY:	Right, okay. So as well as the new Exchange Tower they're building a community arts space. They've commissioned this incredible German Architect and he's going to design it in glass –

She swipes away.

Right, yeah. Well um. This is the green eco hub. They're importing trees from places like Canada, but we'll also have home-grown trees, like – oak trees, or –

She swipes again.

Okay so this is our tech-free yurt space

She swipes again.

Tell you what, do you want to do the Sensory Tour? You get all this information, it's a lot quicker and it's very cool.

ANDREA:	Why not?

ESME enters.

31

JEREMY:	Cool. Ah, Esme! Esme, this lady – I'm really sorry I don't know your name?
ANDREA:	Andrea.
JEREMY:	Andrea, yeah – Andrea would like to do the Sensory Tour.
ESME:	Awesome.
JEREMY:	Brilliant, I'll just go and get the goggles

He leaves **ESME** *and* **ANDREA** *alone.*

ESME:	So where you living at the moment?
ANDREA:	I've been in Spain / but
ESME:	Oh Spain, I love Spain, I went to Barcelona / last year
ANDREA:	But I'm back now.
ESME:	Right.

Beat.

ANDREA:	What have you got, Esme?
ESME:	Sorry?
ANDREA:	Flats, houses…
ESME:	Oh right, well, depends what you're looking for? Three-bed, two-bed, studio…
ANDREA:	I've got a three-bed at the moment but I can probably downsize.
ESME:	Okay. Well, three-beds start from around one and a half. Two-beds, you're looking at something closer to one.
ANDREA:	One?
ESME:	Million. Then one-beds and studios are closer to 600, 700…
ANDREA:	Isn't there a special arrangement for residents?

ESME:	Yeah – all our residents get gym membership, free parking and access to all the leisure facilities.
ANDREA:	No, I meant like a discount? For locals?
ESME:	Oh right. Like – affordable housing?
ANDREA:	That's what I meant by residents.
ESME:	Okay. Well, the affordable housing, those are like – different flats. And there is a limited number of them.
ANDREA:	How much?
ESME:	They're priced at around 80% of market value.
ANDREA:	80% of six or seven hundred thousand pounds?
ESME:	Yeah. But I don't actually have loads of information on that at the moment. I'm not strictly an estate agent. I'm more – freelance.
JEREMY:	*(Entering.)* Esme's actually an actor.
ESME:	Jeremy!
JEREMY:	What? I'm an ambient house DJ. I've got the goggles –
ESME:	Yeah and our boss, Simon, is on lunch – so…
JEREMY:	What's the problem?
ESME:	Er, the Affordables
JEREMY:	Oh shit
ESME:	Yeah. Because we don't have an experience for the affordables
JEREMY:	Tell you what we could do – the studio flats one, yeah? Because they're quite similar
ESME:	Yeah?
JEREMY:	I mean they're almost the same. Some of the views might be a bit – and the finish is – but basically, you know it's / the same thing

33

ESME:	Yeah
ANDREA:	What's that?
ESME:	That's the VR thingy
JEREMY:	You just put it on and it moves with you, so it's like you're walking through the property. Here, let me –

He goes to put the VR goggles on her.

ANDREA:	No, no. I'll do it.

He hands them over. She puts them on.

JEREMY:	I'll just press this?

We hear the music start. **JEREMY** *and* **ESME** *talk amongst themselves. After a moment,* **ANDREA** *pulls the headset off.*

ANDREA:	I can't understand it, sorry. I think it's Chinese
JEREMY:	Oh God sorry, it's on the wrong setting, I forgot to change it

He takes the headset and pushes buttons.

ANDREA:	You've got it in Chinese?
ESME:	It's in Mandarin. We have it in over fifty languages. People buy them from all over the world. It's quite cool.
JEREMY:	Right. Okay. Think that's on the right one now.

He hands it back. **ANDREA** *starts the tour. Eventually,* **ESME** *leaves.*

We hold for a while, listening to the music, watching **ANDREA** *experience the new development. When it finishes, she removes the headset.*

JEREMY:	Are you okay?
ANDREA:	Yeah. Fine.
JEREMY:	Pretty cool isn't it?
ANDREA:	… Yeah.
JEREMY:	Can make you feel a bit queasy

34

ANDREA:	Yes.
JEREMY:	You know what I like to do is go right to the edge of that balcony bit and you look over and you get butterflies but it's crazy isn't it, it's not even real.

Beat.

ANDREA:	Where are all the people?
JEREMY:	What do you mean?
ANDREA:	The people that live here.
JEREMY:	Well I mean, it's just – computer-generated. Graphics. Do you want some water?
ANDREA:	No. I'm fine. You've been very helpful, thanks.

She leaves.

After a moment, so does **JEREMY**.

TV: 1971

A flat.

DEREK SYKES *enters in a mask. He turns to face the audience. Creepy music plays.*

After a moment, he takes up a broom, knocks on the wall with it and then hides, holding the broom like a weapon. We hear **OLD MAN** *from off:*

OLD MAN:	Les. Is that you? Les?

He enters. After a moment sees **SYKES**.

	Oh my god – who are you? Get out.
	Think I'm scared of you? Go on, get out.
SYKES:	Shut up, old man.

SYKES *goes to hit him.* **OLD MAN** *runs out to the phone.*

OLD MAN:	I'm calling the police. I'm calling the police. Hello, police?

SYKES *walks over slowly and snatches the phone away.*

	Please. / Help! Help!

35

SYKES *beats him to death with the phone, shrieking. Then he stands, wipes the phone down and leaves.*

TV: BBC

BBC MAN: The recent release of controversial film *Auto Razor* –
with its delinquent anti-hero, Derek Sykes, committing
random acts of violence against the backdrop of
a concrete high-rise – has sparked heated debate
across the media and even in parliament about the
architectural policy that has seen so-called modernist
estates mushroom across the country unchecked for
decades.

American architecture critic Oscar Newman has
been leading the backlash against such buildings in
the US. Here we take him to the Austen Estate in
London, where *Auto Razor* was filmed, to see if our
architectural legacy will condemn us to the future of
violence, murder, muggings and rape we see on our
film screens.

NEWMAN *moves through the estate. It is the same journey the* **PATHE MAN** *took ten years ago.* **NEWMAN** *throws rubbish as he goes.*

NEWMAN: Yeah, well, this is typical of the new style. You can see
what the architect was thinking. He designed wide
walkways, a river of trees, a 'mere' – that's a sort of
duckpond – in the middle. And it's a beautiful image, a
new image, an image of how people should live in cities.

But this 'beautiful image' is in fact an image of fear.

This building is not a utopia: it is a sore. A stigma.

Cars and children vie for open space. The elderly and
families are housed together in the same buildings.

Because all the property is public, nobody feels a sense
of ownership.

An experiment: we played a tape-recording of a violent argument in a stairwell to see if anybody would come out and help their fellow neighbour.

He presses play on the tape recorder. We hear the argument. We become aware of fearful residents, hiding in doorways.

Nobody came out. Not one person. In fact, the louder the volume, the more curtains were closed, the more doors were locked, the more televisions were turned up – and why?

Because nobody owns this stairwell nobody is willing to defend it. People retreat to the only space they can call their own.

He stops the tape. There is a child. Is it **YOUNG ANDREA**?

There are children growing up here. What happens to these children? Can they ever really feel any sense of responsibility? Will they ever feel any sense of pride?

Now, there is no evidence – as yet – that this type of building produces crime.

But one is compelled to wonder: will these children turn into the criminals that we see on our film screens?

TV: 1972

The flat.

Y.ANDREA *and* **VAL**.

VAL: I've had the school phoning me. I've had to ask Mr Burton "Can I leave now please" and all because of you.

Y.ANDREA: I'm sorry

VAL: What do you mean you're sorry? That's not good enough. What have you been doing? Walking the streets for the last two and a half hours

Y.ANDREA: I didn't think you'd be home.

VAL:	Oh, you thought you could just creep on up there did you… What were you doing?
Y.ANDREA:	I'm sorry, Mum. I just – I –
VAL:	Come on, tell me.
Y.ANDREA:	They were saying horrible stuff and I got upset
VAL:	Horrible stuff? You hit / a girl
Y.ANDREA:	She hit me back
VAL:	You've got to rise above this sort of thing or you're never going to get anywhere.
Y.ANDREA:	Fine Mum, I'm sorry.
VAL:	Why do you always do this to me? Haven't I tried, all the time, to give you everything? And what do you do. You just –
Y.ANDREA:	/ I'm sorry
VAL:	throw it back in my face.
Y.ANDREA:	I didn't mean to
VAL:	What do you mean, you didn't mean to? I don't understand what that means.
Y.ANDREA:	I wasn't trying to upset you
VAL:	I have never, ever been so embarrassed – ashamed – in all my life. Sitting at work and getting a phone call from your school. That school secretary talking to me and I'm having to take it. All the time. Just take it, take it, take it and all because of you.

Beat.

Y.ANDREA *runs to the bathroom*

VAL:	Don't you dare go back up in there don't you dare –

Y.ANDREA *bolts the door before* **VAL** *reaches it. She can't get in. She pounds on the locked door.*

Open this door. Open it. Open it, open it, open it –

Beat.

Fine.

I've got longer patience than you, I can wait, you know that? No tea, no breakfast. You can starve for all I care.

Y.ANDREA: Leave it, please.

VAL: Leave it? Leave it?

Y.ANDREA: Just leave me alone!

VAL: Oh you'd like that wouldn't you? If I left you alone

Y.ANDREA: Yeah, I would

VAL: Yeah, yeah, and who would be providing for you? Eh? Me. Because I'm the one that brought you into this world

Y.ANDREA: I fucking know

VAL: Don't you dare use that language in this house

Y.ANDREA: Fucking leave me alone

VAL: Oh, keep on swearing. I'll still be out here when you come.

Pause.

So what was so important – eh? About what they were saying to you?

Y.ANDREA: You weren't there.

VAL: Yeah. I know. But now you can tell me. What was so important, that you couldn't let it go.

Y.ANDREA: You haven't been there, you wouldn't know.

VAL: Oh wouldn't I?

Y.ANDREA: No

VAL:	Really?
Y.ANDREA:	No
VAL:	Wouldn't I know?
Y.ANDREA:	*(Shouting.)* No, you wouldn't.

Beat.

VAL *screams, pure fury. She empties the rubbish she's collected over the floor.*

After a moment, **Y.ANDREA** *comes out of the bathroom.*

Y.ANDREA:	*(Softly.)* They think you're a joke.
	And I'll – I'll never, ever, ever be one of them. Ever.
	They laugh at us. All the time.
	They were taking the piss out of you and laughing.

Beat.

I'm not even good at school anyway.

Y.ANDREA *walks out.*

VAL *watches her go. She is still. Then she starts cleaning up.*

Music: 'Don't Break The Heart That Loves You' by Connie Francis.

TV: 1973

GRAHAM *enters with a big rucksack.* **VAL** *looks up from her cleaning.*

VAL:	Oh look at you. Don't you look…
GRAHAM:	What?
VAL:	Just so … intellectual.
GRAHAM:	All right Mum.
VAL:	What time's your train again?
GRAHAM:	Not til four, don't worry about it.

VAL:	And do you know how to get to the college when you get there?
GRAHAM:	I'll work it out.
VAL:	What if you get lost?
GRAHAM:	I think they said someone will come and meet me at the train station, so should be fine.
VAL:	And did you remember to pack your new pyjamas? I gave them a wash.
GRAHAM:	Yes, all in here.

Beat.

VAL:	I made you some sandwiches for the journey. Ooh, and I made some jam tarts – that should last you the week – and a fruit cake – that should last you a bit longer, as long as you don't eat too much. Oh, and I've bought a new hot water bottle. Bound to be a bit chilly.
GRAHAM:	That's really kind. Thanks Mum.

Y.ANDREA *enters.*

	Right well / I'd best
VAL:	*(To Y.ANDREA.)* Oh so you're back.
Y.ANDREA:	What you talking about?
VAL:	Your brother's off to university today, did you forget that?
Y.ANDREA:	I'm here aren't I?
VAL:	What's wrong with you
GRAHAM:	Mum it's fine, it's nice that Andrea's here now.

Y.ANDREA *holds up her shopping bags.*

Y.ANDREA:	I'll just pop these in the kitchen.

She leaves.

VAL *goes to* **GRAHAM**. *She presses money into his hand.*

41

VAL:	Here, take this, I don't want you running short.
GRAHAM:	Mum that's really kind but / I'll be okay
VAL:	Take it.
GRAHAM:	Okay. Thanks.
VAL:	Promise me you won't get into any trouble.
GRAHAM:	What?
VAL:	Promise me, Graham.
GRAHAM:	What you talking about?
VAL:	I don't want you throwing it all away
GRAHAM:	Right, okay
VAL:	Graham!
GRAHAM:	Look Mum – I promise I won't get arrested, okay?

Y.ANDREA is watching them through the serving hatch, unobserved.

VAL:	I just want a child I can be proud of.
GRAHAM:	Okay. Look, Mum, I am a bit worried about this train, I'd better get going
VAL:	Give your Mum a hug.

They hug.

GRAHAM:	Bye Mum, I'll see you at Christmas.
VAL:	Give me a ring when you get there, let me know you're safe
GRAHAM:	Yeah I will.
Y.ANDREA:	Don't I get a hug?
GRAHAM:	Course you do.

Beat.

VAL:	I'll go and call the lift.

She leaves.

GRAHAM: What are you doing here?

TV: February 2017

DONNA *and* **RICHARD** *in his flat on the third floor.*

DONNA: Just a routine inspection, you understand?

RICHARD: Oh. Right. Is everything okay?

DONNA: Well, yeah, the property's fine. Not very cosy though

RICHARD: Oh, yeah, I was going to get chairs and stuff but, like the nearest IKEA is miles away and to be honest I've got used to sitting on the floor

DONNA: Minimalist?

RICHARD: Yeah, I guess – but I've got what I need, you know? Got a bed, microwave, kettle

DONNA: Got ladies' shoes

RICHARD: Sorry?

DONNA: I found them in your bedroom.

RICHARD: Oh – shit, yes, they're my girlfriend's. She stayed over last night, she must have forgotten to take them

DONNA: Three pairs?

RICHARD: Well, yes, I mean she comes over like three times a week. Look Donna, I'm not being funny but I get quite lonely in this building and / I ask her to come round a lot

DONNA: Richard, I don't need your sob story okay?
Now, I can turn a blind eye to your girlfriend staying here but you've got to be discreet about it.

RICHARD: Okay yes, cool.

DONNA: Now there is something I do need to talk to you about

RICHARD: Right?

43

DONNA:	Now, the guardian scheme is a helpful arrangement for both of us, and you've been great so far – but we can't have people causing trouble.
RICHARD:	I can assure you I haven't caused any trouble
DONNA:	You're an artist aren't you Richard?
RICHARD:	Yes
DONNA:	Those paints in your bedroom, you use them for art?
RICHARD:	Of course
DONNA:	You don't use them for anything else?
RICHARD:	No. Why?
DONNA:	That 'work' outside, is that yours?

ANDREA *appears. Throughout the below she writes on the wall: '[NAME] lived here.' She does this over and over with different names which also come up on the TV.*

RICHARD:	Oh, you're talking about the wall? No. That's nothing to do with me. I kind of wish it was, what she's doing is pretty cool
DONNA:	*(Firm.)* Who?

— **ABIOYE CISSE**

RICHARD:	It's this lady, she lives upstairs on one of the upper floors, I think she said the fifth floor

LIVED HERE —

— **FELIKS BARTOSIK**

DONNA:	We don't have anybody on the fifth floor.

LIVED HERE —

RICHARD:	No, well I remember she told me – she owns her flat, she's not a guardian.

— **TRACY ROBERTS**

LIVED HERE —

DONNA: Owns it?

— **HALISÍ OBIERO**

RICHARD: Yeah

DONNA: What's she still doing here? Is she causing trouble?

LIVED HERE —

— **TAMMY SCOTT**

RICHARD: No, no –
Look she shouldn't get in trouble for that. We've all seen her do it and nobody's stopped her. I actually think it's really interesting

LIVED HERE —

— **BRIAN DRYDON**

LIVED HERE —

DONNA: Interesting?

— **ABDUL RAHEEM**

RICHARD: I saw her doing it once and she had this incredible anger in her face, you know like a real sense of purpose.

LIVED HERE —

— **RICHARD GERARD**

DONNA: It's vandalism.

LIVED HERE —

RICHARD: Okay – to you maybe. But I think I get what she's doing, it's kind of like a protest

— **GREGORY DRYDON**

LIVED HERE —

DONNA: Against what?

— **KEVIN SYDNEY**

RICHARD: I don't know like…

LIVED HERE —

DONNA: Oppression? Maybe?

— JENNIFER SMITH

DONNA: So she buys her flat for peanuts, sells it for a tidy sum and that's oppression?

LIVED HERE —

— JANE ROBERTS

RICHARD: Okay, as I said, I don't know, I'm just guessing

LIVED HERE —

DONNA: I'm spending half my wage to live in a shoe box –

— HARRY MCGIVER

LIVED HERE —

RICHARD: Okay.

DONNA: You're paying money to live in this shithole nobody else wants

— STEPHANIE THOMAS

LIVED HERE —

RICHARD: Okay well maybe she's lived here a long time, / it's hard to just leave

— KIMBERLY LEESON

DONNA: I volunteer at a shelter for mothers and children who live in shitty B&B's with no hot food and no hot water but you think she's oppressed?

LIVED HERE —

— MAYUR MISTRI

LIVED HERE —

RICHARD: Right. Shit.

— EDUARDO RIOS

DONNA: Sorry Richard, long day.

LIVED HERE —

46

Beat.

RICHARD: Do you want a cup of tea?

DONNA: No I've got other properties I need to get to. Listen, final thing

RICHARD: Yep?

DONNA: We are going to be vacating the building earlier than planned.

RICHARD: How much earlier?

DONNA: We'll need all your stuff out by the end of the month.

RICHARD: Oh. Wow. That was quick

DONNA: Sorry, it is in your contract.

RICHARD: When I moved in, the company said I'd have this place at least a year.

DONNA: The developers want to hurry things up, bring the demolition forward. If you need somewhere else you can contact the office.

— SAAMIR KHAN

LIVED HERE —

— MARK GLEBE

LIVED HERE —

— AADHILA DEUAR

LIVED HERE —

— MARK GLEBE

LIVED HERE —

— CHAU NGO

LIVED HERE —

— MICHAEL JONES

LIVED HERE —

— NICOLA MUNDON

LIVED HERE —

47

RICHARD: What about that lady?

— **MADUENU OKEKE**

Beat.

LIVED HERE —

DONNA: They'll get her out. Court order, cut off the mains – they always find a way.

— **KAM THANDI**

LIVED HERE —

Don't waste time worrying about people like her.

She goes.

TV: 1973

The Austen Estate. Many doors.

VAL *knocks on one.*

SALLY: *(From off.)* Alright, alright, I'm coming.

She answers the door.

What?

VAL: Hello Sally.

SALLY: Who are you?

VAL: I'm Valerie. Welch. I chair the Residents' Association, we met, I think

SALLY: Oh yeah the curtain twitchers.
What do you want?

VAL: Well as you must know, Sally, the bins at Kellynch house were set on fire last Thursday

SALLY: Yeah it stank

VAL: Exactly

SALLY: Came in through the kitchen window

VAL:	And it's not an isolated incident – in fact, vandalism on / this estate
SALLY:	Oh here we go.
VAL:	No Sally, vandalism is a / real problem
SALLY:	Val was it?
VAL:	Yes.
SALLY:	Okay Val. I've got a real problem. It's nine on a Saturday morning and I've got you at my door.
VAL:	Sally, if we don't organise
SALLY:	Val. Val. I couldn't care less about some burning bins.

Another door.

TV: 1974

VAL turns.

VAL:	The Austen Estate is our home. If we don't organise…
SHEILA:	I agree.
VAL:	So you'll come to the meeting, Sheila?
SHEILA:	Yeah, I will.
VAL:	Good.
SHEILA:	Got a good thing going at those meetings haven't you?
VAL:	I beg your pardon?
SHEILA:	Yeah you get things done
VAL:	We try
SHEILA:	Cos I've got a leak in that ceiling. Every time him upstairs flushes, shit water comes into my kitchen.
VAL:	I'm not calling about / individual
SHEILA:	I've got to cook in there Val
VAL:	It's about the communtiy

49

SHEILA:	My heating doesn't work
VAL:	I'm talking about / vandalism
SHEILA:	And I'm talking about your residents' association.
VAL:	What?
SHEILA:	Guess how many times I've called the council?
VAL:	That's none of my business
SHEILA:	Guess
VAL:	I'm not going to guess
SHEILA:	Six times. Bet you don't wait that long Val
VAL:	Excuse me?
SHEILA:	Cosy little deal you've got going with that council
VAL:	I beg your pardon
SHEILA:	Had that new paint job last year, and they fixed your lifts
VAL:	Just exactly what are you implying?
SHEILA:	They haven't touched my block for two years.
VAL:	*(Offended.)* Everything I've done has been for the good of this community.
SHEILA:	Well I'll see for myself. On Thursday.

Another door.

TV: 1975

VAL *turns.*

LEROY THE DOG *barks through the following.*

VAL:	We're trying to sort out the vandalism on the estate. It's not only the bins. There's graffiti on / the walls
SANDRA:	Oh for God's sake shut up Leroy
VAL:	Sorry, is that your dog?
SANDRA:	Yeah what of it

50

VAL:	Because we're not allowed pets on the estate
SANDRA:	He's not a pet he's a pain in the arse
VAL:	Dog mess is one of the biggest problems on this estate, there are children
SANDRA:	Yeah and you don't hear me complaining about the children do you? Talk about vandalism, have you seen what they do in / the walkways
VAL:	It is simply one of the rules of / the tenancy agreement.
SANDRA:	Fucking / rules
VAL:	/ No Dogs.
SANDRA:	Telling me what to do. Leroy! Who are you telling me I can't have a dog, can't paint my bedroom, can't mend my windows when those little pricks smashed them. You fucking nosy bitch. / Leroy!
VAL:	I don't have to / listen to this language
SANDRA:	Sticking your oar in when I've seen your daughter down the pub – absolute disgrace if you ask me. You should be looking out for your own instead of telling me what to do
VAL:	We had to have an interview –

Another door.

TV: 1976

VAL turns.

	– Be respectable. That LCC man coming round my house
BETTY:	Oh I know
VAL:	Checking my kitchen, going through my washing
BETTY:	Asking those questions – do you know what he said to me? He said
VAL:	Oh I don't want to talk about it.

51

BETTY:	But they're certainly not doing interviews now that's for sure
VAL:	No.
BETTY:	It's a dumping ground
VAL:	A what?
BETTY:	A dumping ground. Things I hear through those walls, Val. The screaming that went on last night.
VAL:	What?
BETTY:	Thought he was gonna kill her.
VAL:	And did he?
BETTY:	I don't know.
VAL:	Didn't you knock?
BETTY:	Val! I don't dare.

BETTY *leaves.* **VAL** *is left alone. She steels herself – another door.*

TV: 1977

No answer. **VAL** *waits, then moves to another door.*

TV: 1978

No answer. **VAL** *waits, then moves to another door.*

TV: 1979

No answer. **VAL** *waits, then moves to another door.*

TV: 1980

No answer. **VAL** *waits, then moves to another door.*

TV: 1981

The door swings open. She moves into the flat.

VAL:	Hello?
	Hello?
	It's Mrs Welsh. From the Residents' Association?

There's something bad about the flat. She leaves.

TV: 1976

Music: 'Do You Know The Way To San Jose' by Connie Francis

We're in the flat and **Y.ANDREA** *enters with clothes and an empty suitcase, which she begins to pack onstage.*

She goes back offstage to collect more things, brings them back to pack them.

VAL *enters, watches her.*

Y.ANDREA *continues, oblivious.*

Eventually she does up her suitcase, stands, arranges her scarf in the mirror. It's got an air hostess / holiday rep vibe about it.

She and **VAL** *see each other.*

They almost speak, then the moment passes.

Y.ANDREA *exits with case. She is free.*

VAL *is alone.*

TV: 2017

ANDREA *is alone.*

She's thinking.

Decides something.

Exits to the kitchen.

TV: 1973

VAL *takes up the phone. She makes a call. She waits a while for someone to answer.*

VAL:	Hello? Hello. Oh it's Mrs Welch here, Graham's mum. Usually he answers the phone, is he there?
	Oh, um, oh, what to do. It is 7 o'clock isn't it?
	Because that's when I normally phone him, 7pm on a Sunday.
	Oh, would you? That's so kind of you.

Don't be too long.

Oh. Where could he be?

Would it be worth you giving him a shout along that corridor?

Well you know just shout out his name and he might be in someone else's room.

Thank you.

She waits.

Oh, you've got good lungs on you!

Oh. Oh well um. I wonder what I should do.

Could I ask you to write a little note and put it under his door please?

Thank you.

Just saying that his mum rang and she'll phone again, same time next week.

Oh and I didn't ask your name –

Rupert. That's a lovely name.

Well thanks very much – and yes if you can get him the note.

Thanks Rupert.

Thanks very –

Bye.

TV: March 2017

A street.

WOMAN *enters with VR goggles on.*

ANDREA *enters.*

Looks around.

Holds up a big sheet saying 'I LIVE HERE'

She stands there a while.

Eventually a **SECURITY GUARD** *enters.*

GUARD: Listen Madam, we've been through this before yeah? You can't stand here. Will you please just move? I'm being really polite, yeah, but quite soon I'm going to have to get strict with you. Please, will you just move.

ANDREA *smiles but does not answer.*

Oh my days, she is crazy

The **GUARD** *leaves.*

Beat.

He comes back.

Listen lady yeah, if you don't move I'm going to call the police. I mean it. I'll do it.

Is that what you want? You want me to call the police? Fine.

I'm gonna call them now.

I'm gonna call the police in my booth.

The **GUARD** *leaves.*

Beat. Sirens. The **POLICEMAN** *enters.*

POLICE: Hello madam. Gonna have to ask you to move along now please.

ANDREA: I know my rights

POLICE: Okay. You know your rights. Why don't we move just over here and we can talk about your rights.

ANDREA: I'm allowed to protest

POLICE: Well you are, but not here

ANDREA: That's my town hall

POLICE: Yes, but you're on private land

ANDREA: I'm on the pavement

POLICE: Somebody owns that pavement madam

ANDREA: The council

POLICE: No

ANDREA: This is public land

POLICE:	Look, I'd love to debate this with you Madam, but I'm legally obliged to get you to move on
ANDREA:	But I live here.
POLICE:	Look I'm not going to arrest you, I'm not going to / do anything
ANDREA:	I live here.
POLICE:	Okay. You're more than welcome to protest, if you go round the corner there's a little park, you can protest there as long as you like
ANDREA:	I live here.
POLICE:	I understand that madam
ANDREA:	I live here
POLICE:	Okay
ANDREA:	I live here

She continues repeating this, chanting it through the following.

ANDREA:	I live here	**POLICE:**	Right, okay it's not too late Madam please just stop this.
	I live here		
	I live here		
	I live here		If you carry on like this I will have to arrest you and I don't want to do that.
	I live here		
	I live here		
	I live here		If you don't move on I'm gonna have to use force and I definitely don't want to do that.
	I live here		
	I live here		

ANDREA:	What are you going to do, tazer me?
POLICE:	No, of course I'm not going to Tazer you.

| ANDREA: | Right. | POLICE: | This is ridiculous. |

ANDREA: I live here, I live here –

He goes to touch her and **ANDREA** *lies on the ground, still chanting.*

| ANDREA: | Right. | POLICE: | Oh my god, now she's on the floor… |

ANDREA:
I live here

I live here

I live here

I live here

I live here

I live here

I live here

I live here

I live here

I live here

I live here

I live here

I live here

I live here

POLICE:
Madam, we can do this the easy way or we can do this the hard way, it's up to you.

All right Madam I did warn you, I'm gonna have to do this okay –

He drags her offstage while **ANDREA** *carries on:*

ANDREA: I live here

I live here

I live here

I live here

I live here

I live here

I live here

I live here

I live here

I live here

I live here

I live here

I live here

I live here

I live here

I live here

I live here

I live here

When we can't hear **ANDREA** *anymore, the* **WOMAN** *takes off the VR goggles.*

TV: 1985

The flat.

Y.ANDREA *is sweeping the floor.*

After a few moments, **VAL** *enters through the door with an envelope.*

VAL:	What you doing that for? We can do it in the morning.
Y.ANDREA:	I'll just get it done now.
VAL:	Bit of polishing to do. Won't take any time.
Y.ANDREA:	What you doing up? Shouldn't you be in bed?
VAL:	No, but
Y.ANDREA:	It's alright Mum.
VAL:	Stop it, stop it
Y.ANDREA:	It's alright, it's only a little bit of mess here.
VAL:	Well…
Y.ANDREA:	Couldn't sleep?
VAL:	No.
Y.ANDREA:	Want a cup of tea?
VAL:	No, I'm alright.
Y.ANDREA:	You sure?

VAL *holds out the envelope.*

VAL:	This is for you.
Y.ANDREA:	What's that?
VAL:	Just have a look at it. Go on. Go on, take it
Y.ANDREA:	Shouldn't you be in bed?
VAL:	You be quiet, I'll go to bed in a minute.
Y.ANDREA:	I can look at that in the morning.

59

VAL:	No, no
Y.ANDREA:	I can read it properly then.
VAL:	I want you to look at it now.
Y.ANDREA:	Mum, it's late, please
VAL:	It's for you.

Y.ANDREA *takes the envelope and opens it.*

VAL:	I bought the flat.
Y.ANDREA:	What?
VAL:	I bought the flat.
Y.ANDREA:	Mum, what are you talking about?
VAL:	I wanted to do it for you. I've bought it. I want you to have it.
Y.ANDREA:	How on earth did you manage that?
VAL:	Well…. Well, y'know, I put stuff by and…
Y.ANDREA:	Mum.
VAL:	It's fine. It's for you.
Y.ANDREA:	You shouldn't have done that.
VAL:	What do you mean I shouldn't have done it? Course I can do it
Y.ANDREA:	You shouldn't have wasted your –
	It's all right. We can talk about it in the morning.
VAL:	No no, we've got to talk about it now.
	We've got it. And I want you to have it.

Pause.

	I mean – Graham – he's alright –
Y.ANDREA:	Mum, I don't live here.

60

VAL:	You
Y.ANDREA:	I don't live here, I don't work here
VAL:	/ No, no
Y.ANDREA:	I can't stay here.
VAL:	But you will. When I'm not here
Y.ANDREA:	No
VAL:	You will
Y.ANDREA:	Mum
VAL:	You will
Y.ANDREA:	Mum, I don't want to stay
VAL:	You will
Y.ANDREA:	I don't want to stay here
VAL:	Andrea please
Y.ANDREA:	I don't need it
VAL:	But I want you to have it.

Pause.

	That's all I ever wanted, for you to have a home – and now you do.
Y.ANDREA:	I … don't live here.
VAL	I – I know. But someday you'll come back. And it will be here for you.
	Just for you.
	I don't want you sharing it with Graham, alright?
	Promise me you won't share it with Graham.
Y.ANDREA:	Okay. I promise I won't share it with Graham
VAL:	Good, cos it's yours.

Pause.

Y.ANDREA: Thank you.

They hug.

What have you done you daft cow?

They part.

You shouldn't have done that.

VAL: It's alright. I wanted to do it.

I wanted to do it and now I've done it. And I feel very pleased with myself all right?

Because – the Austen Estate.

It's called the Austen Estate.

Jane Austen.

She's the best.

Y.ANDREA: You go back to bed now alright?

VAL: Okay.

But don't go doing any more down here, okay? I don't want you to.

Y.ANDREA: Alright, well don't you come down either.

VAL: I won't. I can do this lot in the morning. Night, night.

Y.ANDREA: Night.

VAL: Pemberley House. That's Darcy's home.

 VAL *goes. An* **ACTOR** *enters and goes to a mic.*

 Y.ANDREA *alone. She tries to carry on cleaning.*

Y.ANDREA: Shit.

TV: 1813

ACTOR: *(Reading from Pride and Prejudice.)*

	Elizabeth, as they drove along, watched for the first appearance of Pemberley Woods with some perturbation; and when at length they turned in at the lodge, her spirits were in a high flutter.
Y.ANDREA:	Shit, shit, shit.
ACTOR:	They gradually ascended for half a mile, and then found themselves at the top of a considerable eminence, where the wood ceased, and the eye was instantly caught by Pemberley House, situated on the opposite side of a valley, into which the road, with some abruptness, wound. It was a large, handsome, stone building, standing well on rising ground, and backed by a ridge of high woody hills; Elizabeth was delighted. She had never seen a place for which nature had done more, and at that moment she felt that to be mistress of Pemberley might be something.

Y.ANDREA *has finished cleaning. She stands.*

Blackout.

Music: Come Home by Barbara Lewis

TV: A tower block is demolished

And another

And another

And another

And another

And another

Dinomania

Dinomania was first performed on 19 February 2019 at New Diorama Theatre, London.

The cast was as follows:

Janet Etuk

Hamish MacDougall

Sophie Steer

Harriet Webb

Music composed and performed by Zac Gvirtzman

Directed by James Yeatman

Dramaturgy by Lauren Mooney

Production co-design by Joshua Gadsby and Naomi Kuyck-Cohen

Associate design by Lizzy Leech

Stage management by Hanne Schulpé

Additional material by Al Smith

The original production was developed and staged with support from the Royal Victoria Hall Foundation, the Unity Theatre Trust, The Dischma Charitable Trust, the Sylvia Waddilove Foundation, the Thistle Trust, The Geological Society, Theatre Arts at London Metropolitan University and supported using public funding by the National Lottery through Arts Council England. It was commissioned and co-produced by New Diorama Theatre London.

Dinomania was devised by the cast and creative team.

Note

This show could be staged with a company of any size.

We made it with four actors and a musician. The actors doubled as follows:

ONE Mum
 Boy
 Patient
 Mary Mantell
 James Ussher
 Sarah (Servant)

TWO Dad
 Dog
 Doctor Logan
 Jean-Baptiste Lamarck
 Robert Grant
 William Buckland [in part 3]
 Society Member
 Man 1

THREE Horse
 Gardener
 Dr. James Parkinson
 Servant
 Baron Cuvier
 Richard Owen
 Man 2

FOUR Gideon Mantell
 William Buckland [in part 2]

All actors are part of the CHORUS.

PROLOGUE

A space with a piano upstage. In the centre a low platform. Above it a light, which is off.

The piano is being played as the audience enter the space.

The piano stops.

The **CHORUS** *enter.*

A low rumble.

ONE: Three hundred and five million years ago, there was a two-mile square slice of neotropical rainforest on the side of a mountain on the now-lost super-continent Pangea.

TWO: During a period of climate volatility, a heavy rain caused a landslide, felling a copse of now-extinct sigillaria trees.

THREE: They lay where they fell for centuries – undisturbed by fungi and bacteria, which hadn't yet evolved to consume wood – and were covered by layer upon layer of fresher trees over hundreds of millions of years.

FOUR: Gradually, this exposed them to enormous heat and pressure, carbonizing them into a rich seam of coal.

ONE: The coal remained undisturbed until June, when it was mined amongst thirty million tonnes from the Cerrejon mine by the Glencore Mining Company in Colombia.

TWO: It was loaded onto a bulk carrier vessel, and transported to the East Coast of Great Britain, and to a jetty on the Port of Tyne, where it was loaded onto a freight train, powdered and blasted, five minutes ago, directly into the furnace of the Drax Coal-fired Power Station.

THREE: The power station boiled water, which propelled a Turbine, generating electricity; this was fed into the national grid through a series of substations, where it will now be used to turn on this light.

They gesture: a light over the stage turns on.

ALL: *(Sung)* Deus
 Omnibus
 Deus

PART ONE:
YOUNG MAN IN A HURRY

FOUR *lands on the platform and becomes young* **GIDEON MANTELL.** *A baby.* **TWO** *is teaching* **GIDEON** *the origins of the world. Over the following, the noises* **GIDEON** *makes get closer to speech.*

TWO: In the beginning God created the heaven and the earth. And the earth was without form, and void; and darkness was upon the face of the deep. And the Spirit of God moved upon the face of the waters. And God said, Let there be light: and there was light. And God saw the light, that it was good: and God divided the light from the darkness.

GIDEON *makes a sound.* **TWO** *stops. Is he going to speak? No. So he carries on –*

TWO: In the beginning God created the heaven and the earth. And the earth was without form, and void; and darkness was upon the face of the deep. And the Spirit of God moved upon the face of the waters. And God said, Let there be light: and there was light.

GIDEON *makes a sound.* **TWO** *stops. Listens. Carries on –*

TWO: In the beginning God

GIDEON *again. Still not words. Over the following,* **GIDEON** *picks an apple.*

TWO: In the beginning God created the heaven and the earth. And the earth was without form, and void; and darkness was upon the face of the deep. And the Spirit

GIDEON *offers the apple to* **TWO** *with a noise.*

TWO: No. No no

GIDEON's *still offering.*

TWO: No.

GIDEON *withdraws, still looking at the apple.*

71

TWO: In the beginning God created the heaven and the
 earth. And the earth was without form, and void

 GIDEON *spits out the apple he's just tried. But takes another bite over the following.*

TWO: In the beginning God created the heaven and the
 earth. And the earth was without form, and void; and
 darkness was upon the face of the deep. And the Spirit
 of God moved upon the face of the waters.

 GIDEON *throws the apple away.*

TWO: In the beginning God created the heaven and the
 earth. And the earth was without form, and void; and
 darkness was upon the face of the deep.

GIDEON: *(Fast – it's language as object. He doesn't necessarily understand
 it.)* In the beginning God created the heaven and the
 earth and the earth was without form and void and
 darkness was upon the face of the deep and the Spirit
 of God moved upon the face of the waters and God
 said let there be light and there was light and God saw
 the light that it was good: and God divided the light
 from the darkness.

ONE: *(As **MUMMY**.)*
 Gideon. Gideon. Where's Mummy?

 GIDEON *points to her.*

MUMMY: Good. There's Mummy. Can you say Mummy? Can
 you say –

GIDEON: Mummy.

MUMMY: Great. And where's Daddy? Can you see Daddy?

 GIDEON *points to **TWO**.*

TWO: *(As **DADDY**.)*
 Very good.

GIDEON: Daddy.

DADDY: Yes and where's Gideon? Where's Gideon?

72

He looks around. Realises. Points at himself. They cheer.

DADDY: Good!

GIDEON: Gideon.

DADDY: Very good.

There is a **HORSE**.

DADDY: Hey, what's that?

GIDEON: Horse.

DADDY: Yes.

GIDEON: Horse! / Horse!

DADDY: No no careful, / careful, Gideon, Gideon, Gideon!

GIDEON: Horse!

MUMMY: *(Interrupting.)* Gideon, Gideon, where's the dog? Can you see the doggy?

There is a **DOG**.

GIDEON: Dog.

MUMMY: Yeah. Oh, gentle gentle…

GIDEON: Dog!

He strokes the **DOG**.

MUMMY: Good, that's very gentle.

GIDEON: Dog!

The **DOG** *licks him. He starts crying.*

MUMMY: Oh no no no no no, did the doggy lick you? It's okay. It's okay. Gideon, what's that?

GIDEON: Tree.

Through the following, he ages with each answer – from a toddler to a boy.

MUMMY: And that?

GIDEON:	Cat.
MUMMY:	And that?
GIDEON:	Duck.
MUMMY:	And that?
GIDEON:	Bird. Bush. Spider. Grass. Path. Flower. Daisy. Gate. Hill. Field. Pig.
	Butterfly.

A butterfly appears. He follows it. He catches it. It's dead.

Then he sees the mansion.

| | House. Big house. |

He steps off the platform.

The scene becomes –

A COUNTRY GARDEN

GARDENER:	Oi you. What you doing?
GIDEON:	I – I –
GARDENER:	You shouldn't be here.

GIDEON *tries to escape.*

GARDENER:	No, don't run away.
	Don't run away I said.

He catches him.

	What's your name?
GIDEON:	Gideon Mantell.
GARDENER:	Right. Cobbler's son. What are you doing, are you poaching?
GIDEON:	No.

GIDEON *puts his hands behind his back.*

GARDENER: What have you got back there?

GIDEON: Nothing.

GARDENER: Show me your hand. Give it here!

GARDENER *pulls out the dead butterfly. He throws it on the ground.*

This is private land. It's not for you. Go on, piss off.

He shoves **GIDEON** *back onto the platform.*

The scene becomes –

AT HOME

GIDEON: Dad, why can't I go to school?

DAD: You're at school.

GIDEON: No but the Grammar School.

DAD: You know why. They don't take Methodists.

GIDEON: But I'm clever.

DAD: You're doing well at the school you're at.

GIDEON: But I'm really clever.

DAD: Don't answer me back.

GIDEON: But—

DAD: Why do you want to go to Grammar School?

GIDEON: Because then I could be a… a….

DAD: Has someone said something to you?

GIDEON: No.

DAD: They have, haven't they?

GIDEON: No.

DAD:	What did they say?
GIDEON:	Nothing.
DAD:	Come on.
GIDEON:	….
DAD:	I've told you what to say to those people before. Haven't I?
GIDEON:	Yes.
DAD:	What do you say?
GIDEON:	I know what to say.
DAD:	Say it. Say it!
GIDEON:	I may be in a humble station –
DAD:	Louder.
GIDEON:	I may be in a humble station –
DAD:	Good.
GIDEON:	Yet I am a descendant of one of the most ancient families in England. The name Mantell occurs in the list of knights that accompanied William the Conqueror from Normandy.
DAD:	Good.
GIDEON:	The family possessed large manors at Heyford and Rode where many of us bore the honour of a knighthood.
DAD:	Good.
GIDEON:	Dad.
DAD:	What?
GIDEON:	We don't have a knighthood.
DAD:	Get back to your bible.

He's gone.

GIDEON *is alone on stage.*

GIDEON: *(Reciting.)* The earth was corrupt in God's eyes and
 it was full of violence. And God said to Noah, I am
 going to bring floodwaters on the earth to destroy
 all life under the heavens, every creature that has the
 breath of life in it. Everything on earth will perish!

The **CHORUS** *enter. They have fossils.*

CHORUS: *(Sung.)* Deus
 Omnibus
 Deus

They leave the fossils for **GIDEON** *to find.*

He picks them up.

GIDEON: Dad, what are these? Dad?

No answer. He is alone.

 Nautilus.

 Belemnite.

 Ammonite.

He goes to take them off the platform.

The scene becomes –

OUTSIDE

BOY: What's that?

GIDEON: They're fossils.

BOY: Where'd you get them?

GIDEON: I found them.

BOY: Where'd you find them?

GIDEON: I just found them.

BOY:	Oh right. What's a fossil?
GIDEON:	It's an animal, like a –
BOY:	Like what? Like a pet. Like a rock pet.
GIDEON:	No. It's dead.
BOY:	Urggghhh. Don't touch me with it.
GIDEON:	It looks like a snake.
BOY:	Dead rock snake, you're disgusting. What does it do?
GIDEON:	I don't know.
BOY:	You don't know.
GIDEON:	No it's like – it died in the flood. Noah's flood.
BOY:	Why?
GIDEON:	That's what the magazine said.
BOY:	Oh.
GIDEON:	I read about them in *The Gentleman's Magazine*.
BOY:	You can't read.
GIDEON:	Yes, I can.
BOY:	No, you can't. You're not a gentleman.

Beat.

GIDEON:	I may be in a humble station, my parents only cobblers, yet I am a descendant of one of the most ancient families in England. The name Mantell occurs in the list of knights that accompanied William the Conqueror from Normandy. The family possessed large manors at Heyford and Rode where many of us bore the honour of a knighthood.

Beat.

BOY:	You're stupid. What's a magazine?

GIDEON:	Don't you know?
BOY:	Yes. Give me a go then.
GIDEON:	No, it's mine.
BOY:	Don't be tight –
GIDEON:	It's mine.
BOY:	Just a hold.
GIDEON:	No, it's mine / Get away from me.
BOY:	Give it.
GIDEON:	It's MINE.

*He shoves the **BOY** onto the platform, who turns and screams.*

*The **BOY** is now the **PATIENT**.*

The scene becomes –

A LONDON HOSPITAL

DR LOGAN enters holding a gigantic DIY saw.

LOGAN:	Mantell, are you ready?
GIDEON:	Yes.
LOGAN:	What is that?
GIDEON:	They're fossils.

He's still holding the fossils from before.

LOGAN:	What are fossils?
GIDEON:	They're a –
LOGAN:	I don't care. Get rid of it.
	Now, I've got a letter from Doctor Moore and he says you're exceptional.
GIDEON:	Oh – well that's –

LOGAN:	We'll see about that. How old are you?
GIDEON:	Seventeen.
LOGAN:	Ever seen one of these?
GIDEON:	Yes.
LOGAN:	I don't mean the saw. An amputation.
GIDEON:	–
	Yes, I've seen one.
LOGAN:	Fine. Well let's see how good you are.

He holds out the saw.

GIDEON:	No.
LOGAN:	You know what to do. What's the first step?
GIDEON:	I – I –
LOGAN:	'I – I' Come on Mantell! I've got a patient down there, screaming!

*The **PATIENT** screams.*

GIDEON:	Oh god.
LOGAN:	No room for hesitation in surgery.
GIDEON:	Tourniquet.
LOGAN:	Tourniquet. Brilliant. Then what?
GIDEON:	Two quick cuts up through / the
LOGAN:	Through what? Do you even know which bit you're cutting off?
GIDEON:	No.
LOGAN:	Well why haven't you asked, man?
GIDEON:	Which / part of the

LOGAN:	It's the arm. Full amputation of the left arm. What are your tools?
GIDEON:	Scalpel. Incision through the flesh – dividing the muscles –
LOGAN:	What from what?
GIDEON:	Separating the deltoid from the biceps and triceps, splitting those –
LOGAN:	Revealing?
GIDEON:	The humerus.
LOGAN:	Perfect. Then what?
GIDEON:	Capital saw.
LOGAN:	Good, and how long have you got with that?
GIDEON:	Only a minute. Then on to the arteries.
LOGAN:	Clearing them first with the…?
GIDEON:	T – T – Tentacular!
LOGAN:	Good stuff. Then what?
GIDEON:	Then… tar?
LOGAN:	No!
GIDEON:	Sewing! You sew up the arteries.
LOGAN:	*Then* you slap on the tar. Right. Ready to go?
GIDEON:	Uh…

He doesn't want to take the saw. **LOGAN** *is triumphant.*

LOGAN:	Well you're not that fucking good, are you. Fine, I'll do it, but you're going to hold him down. And watch carefully because you'll be doing it by the end of the week.
GIDEON:	Okay.

81

LOGAN *waits.*

LOGAN: … Oh my god, do I have to tell you everything?
 You hide here. They'll be coming in through here.
 The second they come in, bang, you grab them
 under the arm. Meanwhile, I'll be hiding here. The
 second you've got them, I'll come and we'll start the
 procedure. Do you understand?

GIDEON: Yes.

LOGAN: Okay.

 Knock on the door.

A loud knocking.

The scene becomes –

A BEAUTIFUL HALLWAY

GIDEON *enters a remarkable house.*

The servants lead him through to **DR. JAMES PARKINSON,** *who is waiting.*

PARKINSON: Ah, Mr Mantle!

GIDEON: Mantell.

PARKINSON: Gosh, I'm terribly sorry.

GIDEON: No, gosh – I'm sorry – Mantle is fine, whatever you –

PARKINSON: Well how do you say it?

GIDEON: Mantle. No, Mant*ell*. Mantell. Is my name.

PARKINSON: Right. Then we should definitely go with that.

GIDEON: Or Gideon.

PARKINSON: Sorry?

GIDEON: Noth/ing.

PARKINSON: So you're a doctor?

GIDEON:	Oh, just training. In my last year. Walking the hospitals.
PARKINSON:	Barts, isn't it?
GIDEON:	Yes.
PARKINSON:	Is Dr. Logan still there – surgery?
GIDEON:	Yes. Very much so. Do you know him? He's a, he's a –
PARKINSON:	Tyrant.
GIDEON:	…Yes.
PARKINSON:	Clumsy.
GIDEON:	Oh, well I wouldn't –
PARKINSON:	Don't be shy, he's fucking clumsy. Drink?
GIDEON:	Thank you.

We jump forward.

PARKINSON *and* **MANTELL** *each have a drink in their hand.*

GIDEON:	And thank you so much for allowing me into your, your house. It's such a privilege – all your books on geology mean the world to me, and –
PARKINSON:	Oh please, the pleasure's mine. I loved your letter.
GIDEON:	Oh I hope it wasn't, that I didn't sound like a –
PARKINSON:	Like what?
GIDEON:	Well, just like a bit of a –
PARKINSON:	Like what?
GIDEON:	You know, like I'm – a bit – like a –
PARKINSON:	Like a / fan?
GIDEON:	A fan, / yes, exactly.
PARKINSON:	Yeah you did, I fucking love fans.
	So, Mr Mant*ell*. What have you got for me?

GIDEON:	Well it's –
PARKINSON:	Hmm?
GIDEON:	It's – only –
PARKINSON:	Come on.
GIDEON:	I just wanted/ to
PARKINSON:	Don't be such a tease. Show it to me

GIDEON *fetches a fossil.*

	Ammonite! I love ammonites –
GIDEON:	Yes no, me too.
PARKINSON:	Well well well. Hmmm. Gorgeous. Gorgeous.
	I knew you'd be good.
GIDEON:	Well –
PARKINSON:	Right well, let's have a proper shufti shall we?

He puts it on the platform and has a proper shufti.

GIDEON:	I know it's a bit cracked on the –
PARKINSON:	Shut up.
	So where d'you get this? Lewes?
GIDEON:	Yes. It's where I grew up –
PARKINSON:	South Downs.
GIDEON:	Yes.
PARKINSON:	Chalk.
GIDEON:	Yes.
PARKINSON:	Hmmm.
GIDEON:	Do you think –
PARKINSON:	No.

GIDEON:	Oh.
PARKINSON:	No. I've never seen anything like it. This calls for something very special.
GIDEON:	So it's good?
PARKINSON:	Oh, you know it is, you naughty little mouse.
	Come on, we must wet the baby's head.

The servants bring them a better drink.

	Hold my hand. Now – I tip a little – and you tip a little.
	Close your eyes.
	Mantelliceras Mantelli.
GIDEON:	What?
PARKINSON:	What have I got wrong again? Mantle-ic – Mantle-i –
	No, it can't possibly be that –
GIDEON:	No that's not what I – I don't –
PARKINSON:	Well what is it? Because you found it!
GIDEON:	Yes. I.
PARKINSON:	Good. So it should Bear Your Name.

GIDEON *hears his father's voice.*

DAD:	The name Mantell occurs in the list of knights that accompanied William the Conqueror from Normandy. They possessed large manors at Heyford and Rode where many of us bore the honour of a knighthood.
PARKINSON:	Are you alright?
GIDEON:	*(He isn't.)*
	Yes. I'm sorry.
PARKINSON:	Don't apologise, it's overwhelming.
	I'm always crying over fossils.

GIDEON:	It's only –
	I've had that fossil since I was ten. And that letter that I sent you. It's been sitting in my draw in London for three years. And now I qualify next week and I have to leave and be a doctor in Lewes.
PARKINSON:	So?
GIDEON:	I've wasted my time.
	I should have been a geologist.
PARKINSON:	Well, you can't be a geologist in London. You'd be digging up shit. You're going back to Lewes?
GIDEON:	Yes.
PARKINSON:	Terrific. Well that's where it is. We at the Geological Society need to get our fossils from somewhere.
	So go back, be a doctor and carry on.
	I knew you'd be great. From your letter.

The scene becomes –

COUNTRY DOCTOR

A body lands on the platform.

GIDEON *hears* **LOGAN**'s *voice as he treats his patients.*

The patients are made of the same stuff as the fossils – a great mass of bodies building up onstage.

LOGAN:	Right.
	Mantell, what can you see?
GIDEON:	Rose Stevenson. Successfully delivered. Healthy and vocal.

Another body.

But the mother....

LOGAN:	What's wrong with you Mantell? Speak.
GIDEON:	She's still on her side, bleeding profusely. Her face is pale, contorted and gushing with sweat.
LOGAN:	Can you speak to her?
GIDEON:	No – she's just screaming, continually screaming.
LOGAN:	Right, it's too late. Move on.
Body.	
GIDEON:	Mr Taylor of Lewes. Smallpox.
LOGAN:	Go on.
GIDEON:	He's got pustules all over the body. Some of them are weeping, particularly upper torso, left arm, and the groin, causing extreme agony.
LOGAN:	Right, what are you going to do about it?
GIDEON:	Clean the sores, cool the patient to bring temperature down.
LOGAN:	And?
GIDEON:	Prescribe leeches, but we're running out, I can only use two at a time.
LOGAN:	Yeah yeah, move on.
Body.	
GIDEON:	Mrs Daisy Perkins of Hatchfield. Successfully delivered infant female. Weight five pounds three ounces. Lovely healthy baby
LOGAN:	Mantell. Wake up
Body.	
GIDEON:	I'm in a mill, a corn mill. It's loud, there's a lot of commotion. I'm pushing my way through a crowd of workers –

LOGAN:	Yes, what's the problem?
GIDEON:	Young boy, hanging from a post. There's been an accident, his clothing got caught. His left leg has been smashed against a beam.
LOGAN:	What does the leg look like now?
GIDEON:	It's stuck in the machine. It's at an odd angle, bone protruding from the shin. He's screaming and screaming.
	We have to amputate immediately or he'll die from shock.
LOGAN:	Get on with it then.
GIDEON:	He's hyperventilating. Wait. Wait
LOGAN:	What?
GIDEON:	He's stopped screaming.
LOGAN:	What does that mean?
Beat.	
GIDEON:	He's dead.
	He's dead.
LOGAN:	Move on.
Body.	
GIDEON:	Sixty-two-year-old male seems to have an abscess beneath the left ear.
LOGAN:	And?
GIDEON:	Simple, I'll excise the pustular sack with a scalpel and pack the excision wound with a cloth.
LOGAN:	What state is he in?
GIDEON:	He drank a lot of whisky, he's fine.
Body.	
LOGAN:	Next –

GIDEON:	Mrs Tasker of Ringmer. She's still breathing but as far as I can see she has second-degree burns covering the majority of her body.
LOGAN:	How do you deal with that?
GIDEON:	I've applied dressings to the worst of her burns but they're going to need changing every day.
LOGAN:	And who can do that?
GIDEON:	Me.
LOGAN:	Are you crazy, Mantell? You don't have time.
GIDEON:	I'll make time.
LOGAN:	Fine. Move on.

Body.

GIDEON:	Now there's an abscess of the molar, huge blackening decay, gums bleeding.
LOGAN:	Do you take it out?
GIDEON:	Yes, immediate extraction.
LOGAN:	Move on.

Body.

GIDEON:	A one-year-old infant, the breathing is slowing, his fever is high. I don't hold out much hope.
LOGAN:	Move on.

Body.

GIDEON:	Syphilis, prescribing mercury pills.
LOGAN:	Move on.

Body.

GIDEON:	Healthy baby boy, mother fine.

LOGAN:	Next.

Body.

GIDEON:	Healthy baby girl, mother fine.
LOGAN:	Next.

Body.

GIDEON:	Healthy baby girl, mother fine.
LOGAN:	Next.
GIDEON:	Mr. George Woodhouse.

The scene becomes –

MARY WOODHOUSE'S DRAWING ROOM

MARY:	Dr Mantell.
GIDEON:	Mary.
	How has he been?
MARY:	He was alright yesterday. But this morning –
GIDEON:	Coughing again?
MARY:	Terribly.
GIDEON:	Did you try the –
MARY:	Laudanum?
GIDEON:	Yes.
MARY:	A few times.
	And it worked – for a time – but –
GIDEON:	You must be exhausted.
MARY:	It's fine. I tried to encourage him to sleep on his / side.
GIDEON:	And?

MARY: He did to start with but then he'd roll onto his back and / wake up.

GIDEON: Wake up?

MARY: I tried to encourage him to take some air but he won't listen.

GIDEON: / We can.

MARY: I tried to cool him down. I tried eucalyptus, tended to his fever –

GIDEON: Mary –

MARY: But he keeps slipping –

GIDEON: Mary –

MARY: He's slipping and slipping, and

GIDEON: Mary.

He takes her hand.

You are quite wonderful.

MARY: Am I?

GIDEON: Yes.

She hugs him.

They draw apart, embarrassed.

MARY: Sorry.

GIDEON: May I?

He goes. She is left alone.

Two **SERVANTS**.

SERVANT: Alright, Thomas, get these shifted.

THOMAS *clears the pile of bodies from the stage, into the corner.*

What you doing?

MARY:	Nothing.
SERVANT:	Your father is dying in there.
MARY:	I know.
SERVANT:	And you're wearing your best dress.
MARY:	It's the only one that was clean.
SERVANT:	Liar.
MARY:	Shut up –
SERVANT:	Thomas. I think we'll leave Miss Hussy to herself.

SERVANTS *leave.* **GIDEON** *comes back.*

	How is he?
GIDEON:	Sleeping.
	Well I *[should go]*…
MARY:	For you.

She gives him a fossil.

GIDEON:	What?
MARY:	They're corals.
GIDEON:	Corals?
MARY:	I found them. In Worcestershire. I know they're not much, but you said you liked –
GIDEON:	– rocks. I do.
MARY:	How is he?
GIDEON:	Dying. I'm sorry.
MARY:	Don't be. You've done so much.

A new day.

GIDEON:	I found you a –

MARY: Belemnite!

GIDEON: Yes.

A new day.

MARY: I found you an ammonite.

She wants him to take the plunge.

 Yes.

GIDEON: But your father –

The music is full Brief Encounter.

MARY: Oh I don't care! I love you.

They are about to kiss when the body of her father lands onstage.

The **SERVANTS**.

SERVANT: He said he could die happy knowing that you would be
 her husband.

They take the body away.

MARY *and* **GIDEON** *embrace.*

They are surrounded by butterflies.

They lie down centre-stage, on the platform, but **MARY** *feels something underneath
her back.*

A fossil.

It doesn't look like the others.

MARY: Gideon – what's this?

ALL: *(Sung.)* Deus
 Omnibus
 Deus

PART TWO:
THE DEBATE

An unreal space.

JEAN-BAPTISTE LAMARCK *takes to the platform and addresses the audience.*

The rest of the company are the **CHORUS** *and occasionally step forward to become named characters.*

LAMARCK:	My lords, I've come here today to speak about nothing less than the age of the earth and the origin of life. For two hundred years we have broadly accepted the doctrine of archbishop Ussher –
USSHER:	*(Entering.)* My lords. After many years of scholarship, reading Hebrew and Greek texts I discovered nothing less than the day on which the earth was created. Working back from the birth of our lord, Amen
CHORUS:	Amen.
USSHER:	Through the bloodlines of David, Moses and Abraham to Noah, who was begotten by Lamach who was begotten by Methuselah who was begotten by Enoch who was begotten by Jared who was begotten by Mahalalel who was begotten by Keenan, who was begotten by Enoch who was begotten by Seth who was begotten by Adam, who lived for 930 years after he was made on the sixth day of creation, I can say to you now unequivocally that the beginning of time happened at the start of the evening preceding the 23rd day of October 4004 BC.
LAMARCK:	My lords, I respect the venerable archbishop's scholarship. All I ask is you consider this.
USSHER:	What's that?
LAMARCK:	It's a fossil.
USSHER:	What's a fossil?

LAMARCK:	Have a look.
USSHER:	Absolutely not.
LAMARCK:	Well to my understanding it is the remains of an animal that has been entombed within a rock. My lords, this animal must have lived, died and turned to stone. All I'm asking the archbishop to consider is how that can be possible in just 6000 years.

USSHER is unsure how to answer this.

USSHER:	Erm. Well.
	Well, I'm dead actually. I died 150 years ago so – it's very sad – so I'm not actually the right person to…

He steps away.

LAMARCK has the stage to himself again.

LAMARCK:	My lords, I propose that this fossil suggests the age of the earth is so great that it is beyond the power of man to imagine. I'm speaking not in thousands of years but in millions of centuries.
CHORUS:	*(Sung as opera.)* Blasphemy! Blasphemy! Blasphemy!

One of the CHORUS becomes DR. JAMES PARKINSON, who takes to the platform.

PARKINSON:	My lords, my lords, my lords, I beg you to calm down. There really is no need to get so hot and bothered.
	Nice try, Mr. Lamarck. He's tried to frighten you all with the amount of time it takes to make a fossil.
	Well don't worry, because if you take the fossil record, the order in which they have all been found in the strata, there is nothing – nothing – that contradicts what we have read in the bible.

He displays different fossils.

In the deepest layers we find the molluscs, then we find the fish, then the reptiles and the birds and finally the mammals.

The order of creation is exactly as we find in Genesis.

We just need more time.

Now, I propose that the days of creation are not days as we understand them to be.

CHORUS: *(Sung.)* Blasphemy!

PARKINSON: Gentlemen, please!

What is a day to God? Could each day not be – an age? Day 1, a million years. Day 2, another million years. Day 3, day 4, day 5…

Enough time for an animal to live, die and turn to stone. All before the sixth day when man was created – 6000 years passed and here we all are. If we allow for this deep time, everything the Bible proposes is possible.

So, thank you.

He exits and **LAMARCK** *retakes the stage. He also displays fossils.*

LAMARCK: Then how, my lords, do you explain these?

Species of molluscs, leaves, lizards that are completely extinct – they no longer exist anywhere on this earth.

And I ask my learned peers, what God would create a whole species only to destroy it?

The **CHORUS** *don't know. Enter* **WILLIAM BUCKLAND**.

BUCKLAND: My lords, of course – the flood!

CHORUS: Huh?

BUCKLAND: Noah's flood!

CHORUS: Eh?

BUCKLAND:	When God destroyed all life on earth, come on –
CHORUS:	Oh the flood!
BUCKLAND:	– except, of course, for what was saved in the ark.
	And what's more Mr Lamarck, I can prove it. I can prove it in the earth itself. Yes, I can prove it in the gravels.
CHORUS:	Oh, the gravels, the gravels!
BUCKLAND:	From Worcestershire to Stow-on-the-Wold there is a trail of gravel that can be nothing less than the beach created by the breaking of Noah's great wave.
	Further proof, Mr Lamarck: among the gravels in Kirkdale I discovered a cave filled with the bones of an extinct species of giant hyena.

One of the **CHORUS** *becomes a growling hyena.*

	A fearsome beast that once stalked the moors of Yorkshire. And became a victim, my lords, of God's wrath.
CHORUS:	Shoot the hyena!
LAMARCK:	*(Sung.)* Ha! Hyenas in Yorkshire.
	(Spoken.) But what does that really tell us?
CHORUS:	*(Sung.)* Nothing, they're dogs.
LAMARCK:	But what does that say about the climate of Yorkshire?
CHORUS:	*(Sung.)* It's shit.
LAMARCK:	No, that it was hot. That it was very hot.
CHORUS:	*(Sung.)* It's not hot, it's shit.
LAMARCK:	No, that Yorkshire was once tropical.
CHORUS:	*(Sung.)* Yorkshire's never been tropical, it's always been shit.
LAMARCK:	My Lords, if a flood killed hyenas in Yorkshire, what are we saying about the world?

	This isn't about one flood, it's about generations of disorder. Everywhere you look there are fossils that shouldn't be there. Palm trees in Germany. Shellfish on top of mountains. If environments can change so dramatically, then so can animals, and so can people.
CHORUS:	*(Sung)* What is he saying?
LAMARCK:	What if nothing ever went extinct at all? What if all life is one great progression? Our tropical Yorkshire hyenas become wolves, our worms become snakes… And is it not possible that the simplest mollusc, under the most favourable conditions, and over millions of years, might strive to reach the complexity of man?

Beat.

CHORUS:	*(Sung)* Hang on, mollusc to man. Are you saying I'm a fish?
LAMARCK:	No, I'm not saying / you're a –
CHORUS:	*(Sung)* I'm not a fish.
LAMARCK:	This is ridiculous.
CHORUS:	*(Sung)* God made man in his image!
LAMARCK:	God made the world, he just didn't make it how you want it to be. My lords –
CHORUS:	*(Sung)* Lords!
LAMARCK:	You don't want a mollusc to become a man because you can't bear the idea that a peasant could become a king. The problem with this whole organisation is it's riddled with aristocrats trying to force nature to justify their bankrupt position. That is the truth. If you just looked at the evidence –

Big chords. Enter **BARON CUVIER**.

CUVIER:	What evidence, Mr Lamarck? What evidence?
LAMARCK:	Baron Cuvier!

They bow.

	The – fossil evidence – points to a progression from simple–
CUVIER:	There is no evidence.
	How does it happen?
	How does a mollusc become a man?
LAMARCK:	Life… finds a way.
CUVIER:	He doesn't know!
	He. Doesn't. Know. Because I tell you, my lords, for Mr Lamarck's theory to be correct, if all life was progressing, we wouldn't have animals as we know them at all. We would have half an animal trying to be another animal. We would have – a spider – striving to become a lion.
CHORUS/1:	Preposterous!
CHORUS/4:	Web of lies!
CUVIER:	You would have a crocodile aspiring to become a pig…
CHORUS/1:	Crocopig?
CHORUS/4:	Crock o' shit.
CUVIER:	Where's the evidence for that, Mr Lamarck?
LAMARCK:	I obviously don't have evidence for a spider –
CUVIER:	What's your speciality?
LAMARCK:	…Worms.
CUVIER:	Yes.
	Because I control the Musee Nationale d'Histoire Naturelle in Paris.

CHORUS *bring on the museum. It's a big box.*

The world's greatest anatomical collection.

Let me show you a lion.

CHORUS *give* **CUVIER** *a gun. He shoots into the box and pulls out a lion. It's made of the same stuff as* **MANTELL**'*s patients and the fossils.* **CUVIER** *drags the lion bodily onto the platform.*

CUVIER: Here.

Now would we not all agree that this lion couldn't be anything but a lion?

It was perfectly designed for its function.

What is a lion? It's a carnivore. And to see a lion hunt its prey is to see all of its anatomy working in unison for one sole God-given purpose. Strong limbs for chasing, sharp teeth for ripping flesh, and a jaw strong enough to kill.

Tell me, Mr Lamarck. Which part of this animal is a mollusc *improved*?

LAMARCK *can't answer.*

Everywhere you look, life belongs to the categories in which God placed them.

Nowhere in nature are there reptilian bones in the body of a mammal, or the heart of a bird in the skeleton of a fish.

LAMARCK: With more research –

CUVIER: You won't be doing any more research.
In fact. What are you even doing on this platform? You shouldn't be up here.

LAMARCK: But what about extinction, you haven't answered –

CUVIER: I have a responsibility to uphold the religious values of this Society.

LAMARCK: When I publish my –

CUVIER:	You won't be publishing anything, Mr Lamarck. Thank you for contribution.

CUVIER *shots* **LAMARCK.**

He drops.

A breath.

He becomes anatomist **ROBERT GRANT.**

GRANT:	But my lords!
CUVIER:	What?
GRANT:	The baron fails to answer Lamarck's question:
CUVIER:	*Excusez-moi?*
GRANT:	– why extinction at all?
CUVIER:	This is my platform!
GRANT:	My lords, he has –
CUVIER:	Who even are you?
GRANT:	I am Robert Grant, anatomist, a faithful disciple of Lamarck and, my Lords, the God that Cuvier describes seems to be endlessly making animals, only to destroy them – his God is some kind of fickle tinkerer.
CUVIER:	I don't claim to describe God's intentions, merely his works.
GRANT:	Well you're describing them wrong. You claim there can never be a crossover between the categories of animals.
CUVIER:	Correct.
GRANT:	That there's nothing of the mammal in a lizard or the fish in a bird. So how do you explain this?

He holds out a fossil.

CUVIER:	What's that?

GRANT:	That's obviously the fossilised snout of an extinct crocodile.
CUVIER:	Okay.
GRANT:	And do you see here, my dear baron –
CUVIER:	Don't patronise me.
GRANT:	Take a good old look up its nose. What do you see? What do you see?

No response.

	What he's not telling you – but what I am sure he has by now observed – is that the structure of that nasal canal is distinctly mammalian. That. Is a mammal's nasal canal.
CUVIER:	How dare you even suggest –
GRANT:	A mammal's nasal canal in the head of a reptile. How do you explain that?
CUVIER:	Bollocks.
GRANT:	Everywhere you look, nature shows us that we're all related.
CHORUS:	*(Sung repeatedly under the following.)* Creatio Creatio
CUVIER:	No, it's bollocks.
GRANT:	An animal's anatomy isn't boxed into rigid categories – this must be a mammal, this must be a reptile and never the twain shall meet.
CUVIER:	God made each of us –
GRANT:	Always you find similarities, homologies – links – between the wing of a bat, the fin of a fish, the hand of a man, proof that we are not individually created but descended by an uninterrupted path of generations.

CUVIER *is increasingly apoplectic.*

CUVIER: How *dare* you speak of the human hand? You would
 come in and take away the God from man, the divine
 spark that lifts us from the beasts. You would burn the
 Bible and throw us into the menagerie!
 Mr Grant, you would have us rolling in the sty, rutting
 like pigs in in in shit…

The CHORUS *stop singing.*

 shit ….shit…. shit …shit.

CUVIER *dies.*

The CHORUS *screams.* GRANT *silences them.*

GRANT: Finally, my lords, I can let the science speak for itself.
 I have here a letter from Lieutenant Maule of the New
 South Wales garrison in Australia, bringing news of a
 new animal: the duck-billed platypus. A warm blooded
 creature, so apparently a mammal but which, my lords,
 doesn't produce milk and lays eggs – the exact thing
 which Cuvier described as impossible – a mammal
 with the reproductive organs of a reptile. Living proof
 at last that animals can change, so –

CUVIER *springs up – he has become* RICHARD OWEN.

OWEN: But is there proof?
 I'd love to see it.

GRANT: I'll take questions afterwards. Let me explain –

OWEN: *(Offering his hand.)* Richard Owen, Royal College of
 Surgeons.

GRANT: Great, let me explain this letter to you.

OWEN: Do you have a specimen?

GRANT: No. I –

OWEN: So it's just a letter?

GRANT: Will you stop interrupting me?

OWEN:	Sorry, I'm not being – it's just you're trying to remove God from creation, you're trying to upend the natural order, on the evidence of – what? A letter? Don't you want to see the creature for yourself?
GRANT:	Well, it's in Australia, so –
OWEN:	I know.
GRANT:	So. I can't just go to Australia. My lords, I've got drawings –
OWEN:	Drawings? Ah. Because you see, the great thing about being at the Royal College of Surgeons is we have new specimens arriving every day. From the colonies. In the new world.

Doorbell sound.

CHORUS/1:	Platypus delivery.
OWEN:	Perfect. Now – Mr Grant, you contend that this animal, in all other respects a mammal, has the reproductive organs of a reptile.
GRANT:	Yes.
OWEN:	Because…
GRANT:	It doesn't produce milk. It has no teats. It has no mammary glands. Mammals suckle their young and this animal can't.
OWEN:	Well, shall we take a look? Let the science speak for itself?
GRANT:	Sure.
OWEN	Do you want to do the honours?

GRANT *aims into the box and shoots the platypus.*

I'll skin it shall I?

OWEN *stabs the contents of the box with a knife.*

There.

A jet of milk.

> Milk, oozing through her fur.

He's holding a bottle of milk.

> The babies, my lords, don't need teats to suckle, they lick the milk off the fur.

GRANT: Who says that's milk?

OWEN: Come on, that is milk!

GRANT: That could be anything, it could be –

OWEN: It's milk. It's milk. There is nothing reptilian about the platypus and you know it!

GRANT: But there are others, I have other examples, I can show the Society –

OWEN: The Society's very busy.

GRANT: But it's my right as a member –

OWEN But you're not a member.

GRANT: What?

OWEN: I'm afraid there was a blackball against your name.

GRANT: When was that?

OWEN: It doesn't matter.

GRANT: But I need the specimens if I'm going to –

OWEN: No.

GRANT: But. I'll lose my career. I'll lose…

> No, no, no –

The **CHORUS** *drag* **GRANT** *to the back of the stage and shoot him.*

The meeting is over.

PART THREE:
DINOMANIA

We see a dumb show to music: **GIDEON** *and* **MARY**. *As before, she finds the tooth. They look at it together in wonder until he sees a butterfly.*

It's an echo of the butterfly we saw in Act One.

The butterfly lures **GIDEON** *away from* **MARY**.

As he steps off the platform, the actor puppeteering the butterfly hits **GIDEON**. *Hard. Really hard.*

GIDEON *is hurt. Gets back on the platform.* **MARY** *tries to comfort him, but the butterfly comes back.*

Again he goes after it and is hurt.

Again.

And again.

Unable to watch any longer, **MARY** *goes off stage and leaves him.*

He tries again. And is hurt again. Badly this time.

His back twisted. He is alone. Older.

GIDEON:	Mary?
	Mary?

The scene becomes –

BUCKLAND'S DRAWING ROOM

GIDEON, *older, still injured and bent strangely. He can barely turn.* **BUCKLAND** *greets him.*

BUCKLAND:	Gideon, so nice to see you. Thank you for coming.
GIDEON:	William. Thank you for inviting me, it's a treat.

BUCKLAND:	No no no. Listen, I was so sorry to hear about your accident.
GIDEON:	Please, don't worry. Your letter was –
BUCKLAND:	I was going to come and visit you but my wife – she / has this –
GIDEON:	Please. It's – lovely to see you.
BUCKLAND:	Is there anything we can do?
GIDEON:	No, no. No trouble, no fuss.

He sees **OWEN**.

	Mr Owen. Such a pleasure.
BUCKLAND:	Oh my goodness, how rude. I keep forgetting you've never met.
	Richard Owen. Gideon Mantell.
GIDEON:	Mr Owen. I read your paper on the platypus.
OWEN:	Oh?
GIDEON:	Very fine work.
OWEN:	Thank you.
BUCKLAND:	Richard was just saying to me, I've got this right, haven't I, that he was there – you were there weren't you? – when you presented the Iguanodon for the first time.
OWEN:	I was.
BUCKLAND:	What was it, fifteen years ago?
OWEN:	It was. It was fifteen years.
BUCKLAND:	He was a student. Wet behind the ears.

An awkward pause.

	Hm. Time.
	Drink?

OWEN:	Not for me thanks. Mr Mantell –
GIDEON:	Mr Owen?
OWEN:	Such a pleasure. I don't know if William told you but I'm preparing a paper at the moment and your collection at the British Museum's been invaluable.
GIDEON:	How is it?
OWEN:	Sorry?
GIDEON:	My collection. How is it?
BUCKLAND:	Such a tragedy.
OWEN:	Well, it's the best. You must know it's the best.
BUCKLAND:	Of course…
OWEN:	I've been tasked by the Royal Society –
GIDEON:	Yes, William said –
BUCKLAND:	Gideon, you are looking at the man who's taking the fight to the progressionists single-handed! He's smashed them on the platypus and now the next front is opening up on the reptiles.
OWEN:	The fossil reptiles.
BUCKLAND:	Exactly.
OWEN:	I've been tasked to present a paper on the British Reptiles. We're all very concerned, as you must be, Mr Mantell, that your great discovery, the Iguanodon, is going to be claimed by the progressionists as proof of evolution.
BUCKLAND:	As if the mighty Iguanodon was just a mere staging post on the way to – to – an iguana.
OWEN:	I want to claim it for God.
GIDEON:	Amen.

OWEN:	Exactly. Mr Mantell, these last months I've travelled the country looking at every shred of fossil evidence I can find. I've seen collections in Lancaster and Newcastle –
BUCKLAND:	Yes, he's been riding the *train*! Have you been on one yet, Gideon?
GIDEON:	No.
BUCKLAND:	No. No, of course.
OWEN:	Mr Mantell, for this paper to be what it needs to be, I need – all the evidence. In my hands. I need everything.
GIDEON:	Yes, I quite understand.

A servant, SARAH, enters.

SARAH:	Mr Buckland?
BUCKLAND:	Not now, Sarah.
SARAH:	No but Mr Buckland –
BUCKLAND:	Sarah!
SARAH:	It's Tiglath.
BUCKLAND:	What?
SARAH:	He's *loose*.
BUCKLAND:	Where are the children?
SARAH:	Lucy's locked in the scullery, but the last I saw, Johnny was in the garden and now I can't find him...
BUCKLAND:	Good God. I thought this might happen.

He takes out a gun and inadvertently points it at her. She screams.

God, sorry, that wasn't—

Now, Sarah: go and lock yourself in the lavatory.

Gentlemen, I'll trouble you to lock the door behind me.

If you'll excuse me.

They both go out, leaving the two of them alone.

GIDEON: Who's Tiglath?

OWEN: His bear. He keeps a live bear.

GIDEON: Of course.

OWEN: I'll get the door, shall I?

OWEN *locks the door.*

OWEN: Mr Mantell, we have a problem. The British Museum has every fossil you've ever recorded finding.

GIDEON: Yes.

OWEN: Except the tooth. That first Iguanodon tooth.

GIDEON: …

OWEN: Do you have it, Mr Mantell?

GIDEON: Yes.

OWEN: May I see?

GIDEON *holds his hand out.*

Brilliant.

OWEN *goes to take the tooth.* **GIDEON** *immediately pulls it away.*

I –

GIDEON: Mr Owen. I will give you this tooth. But you must understand – it's mine.

OWEN: Mr Mantell.

GIDEON: I found it.

OWEN: We are gentlemen of science…

GIDEON: Please. You must understand. The Iguanodon is mine.

The 22rd October 1820. Early evening. I remember it
like –

A yell as the injuries to his spine are undone.

The scene becomes –

THE TILGATE FOREST

It is 1820 – but **GIDEON** *is still addressing* **OWEN**, *a ghost from the future, who watches everything.*

GIDEON: I was delivering another baby.

LOGAN: Mantell, what can you see?

GIDEON: Anne Nicholson 6lbs, healthy.

LOGAN: What about the mother?

GIDEON: It was far from my usual patch, near a rocky outcrop in the Sussex Weald.

LOGAN: Come on!

GIDEON: The Tilgate Forest.

LOGAN: The mother!

GIDEON: She's fine, she was fine.
I walked out of the woman's low cottage, and there was Mary. She was picking over a pile of stones next to a small quarry. She saw me. She was smiling.

We see her.

Holding out her hand.

MARY: Gideon.

GIDEON: Holding the smallest thing.

MARY: I've found something.

GIDEON: Hardly bigger than a pebble.

MARY: What is it?

GIDEON:	Sometimes, years later, as I pored over it for the thousandth time, I would doubt – surely, it couldn't be? But the feeling would always return, the jolt, the shock of glimpsing.
MARY:	What is it?
GIDEON:	A tooth.
MARY:	A tooth?
GIDEON:	Entombed in stone for who knows how many millions of years. Ours were the first eyes to fall on it. This tooth.
MARY:	More than an inch long. Flat. Worn down. Shaped into a grinding surface at the crown. What kind of tooth?
GIDEON:	That was the question. A tooth like this, flat on top –
MARY:	It has to come from a herbivore.
GIDEON:	Exactly. But the herbivores this size are mammals.
MARY:	And this quarry, these rocks, they're old.
GIDEON:	And no mammal's teeth have ever been found in rocks this old…
MARY:	Only reptiles and fish.
GIDEON:	So it can't be a mammal.
MARY:	It has to be a reptile.
GIDEON:	But Mary – what reptile had teeth this big?
MARY:	We have to find out.
GIDEON:	(*To* **OWEN**.) On weekends we rode out together, digging deeper into the rocks. The two of us together in a Sussex quarry. They were the happiest days of my life.
MARY:	Gideon, look.
GIDEON:	We looked – and fragments of a vanished world began to emerge.

Fossils everywhere. They are almost alive.

MARY: Plants. Trees.

GIDEON: But not British trees.

MARY: Palm trees.

GIDEON: Tropical Ferns. A lush ancient forest under this field in England. Filled with enormous creatures, fragments of which were beginning to emerge –

MARY: A horn.

GIDEON: Vertebrae

MARY: Toe bones

GIDEON: And this. The end of a thigh bone which must have been five feet long.

Just imagine, Mary. Just imagine.

An animal of the lizard tribe, three or four times as large as the largest crocodile, having jaws with teeth equal in size to the incisors of the rhinoceros, walking beside an estuary formed by a mighty river flowing in a tropical climate over sandstone rocks through a landscape of arborescent ferns and groves of palms that to him were nothing more than blades of grass, such was the magnificent size of my mighty beast.

For a brief moment, we see the beast.

It only needed a name.

We hear **MANTELL**'s *father again.*

DAD: The name Mantell occurs in the list of knights that accompanied William the Conqueror from Normandy. They possessed large manors at Heyford and Rode, where many of them bore the honour of a knighthood.

The scene becomes –

113

THE GEOLOGICAL SOCIETY OF LONDON

It's a little like the staging we remember from Part Two.

GIDEON: *(To OWEN.)* This was my chance. I wrote everything I'd discovered into a book.

Mary did the illustrations.

MARY: Good luck.

GIDEON: *(To OWEN.)* And took it to the Geological Society.

(To the SOCIETY.) My lords – please may I present my manuscript.

They stop talking. It's like when somebody walks into a bar in a Western. Awkward.

SOCIETY 1: Manuscript?

He hands over the book.

(Reading.) Illustrations of the Geology of Sussex: A General View of the Geological Relations of the South Eastern Part of England with Figures and Descriptions of the Fossils of the Tilgate Forest.

Blimey. Couldn't you have just sent the fossils? Left the writing to us.

GIDEON: My lords – if I may?

SOCIETY 1: *(Surprised.)* Be my guest.

MANTELL *takes the stage.*

GIDEON: My lords. I am honoured to present to you a new discovery. From this tooth alone, I have made quite certain of my discovery – which is to say, that this tooth is the remnant of a giant herbivorous lizard, the likes of which have never been seen before.

I have had the tooth examined, my lords, by experts, who claim that – although it is forty times the size of any living reptile's tooth – it most resembles that of the iguana.

I therefore name this vanished creature – the Iguanodon.

A pause.

SOCIETY:	*(Sung.)* IMPOSSIBLE
GIDEON:	My lords –
SOCIETY:	*(Sung.)* RIDICULOUS
GIDEON:	If you could just look at the –
SOCIETY:	*(Sung.)* NONSENSE.

*The eminent society member who has already spoken (**SOCIETY I**) quiets the room with total authority. He reclaims control of the stage.*

SOCIETY 1: My lords, why is this man – a country doctor, an amateur – wasting our time with claims of an impossible animal? Giant herbivorous lizard – yes, my lords, what we have here is a fantasist. All he has is a tooth, a leg bone, and a horn, and from these invents a gigantic monster completely unknown in God's creation.

There's no reason to suspect the tooth belonged to anything other than a large mammal, sadly drowned in Noah's flood.

SOCIETY 2: Amen.

SOCIETY 1: Yes, Amen. In conclusion: it's a bloody rhino.

*He aims the gun at **GIDEON**.*

GIDEON: No, please!

SOCIETY 1: Don't worry, old chap.

He pockets the gun.

Stick to the day job, eh? There's a good fellow.

The scene becomes –

THE MANTELLS' HOME

MARY: What did they say?

Gideon?

No answer.

	Gideon, what did they say?
GIDEON:	They said it's a rhino.
MARY:	What? No. There must be –
GIDEON:	They didn't believe me, Mary.
MARY:	There must be some mistake.
GIDEON:	They didn't believe me.
MARY:	Gideon. Let's just take some time –
GIDEON:	I don't have *time*, Mary. I'm right.

*The memory of **LOGAN** returns – he's pelting **GIDEON** with bodies. Throughout the following, **GIDEON** continues speaking to **OWEN**, battling against the bodies piling up on the platform.*

LOGAN:	Right Mantell, what are you looking at?
GIDEON:	I doubled down.
LOGAN:	Gangrene in the foot.
GIDEON:	Every moment I had,
LOGAN:	Boy, sixteen, crushed by a horse.
GIDEON:	every hour that I wasn't seeing patients,
LOGAN:	Old lady, cataracts.
GIDEON:	mornings, evenings, weekends,
LOGAN:	Tertiary syphilis.
GIDEON:	I was in the quarries, chipping away.
LOGAN:	Fractured skull.
GIDEON:	Looking for proof.
LOGAN:	Cholera.
GIDEON:	Proof that I was right,

LOGAN:	Cholera
GIDEON:	that they were wrong.
LOGAN:	Cholera.
GIDEON:	That my Iguanodon did exist.
LOGAN:	Cholera.
GIDEON:	I needed anything – a skeleton, a skull, a jaw –
LOGAN:	Cholera.
GIDEON:	But there was nothing.
LOGAN:	Spiral fracture.
GIDEON:	Just fragments,
LOGAN:	Shattered pelvis.
GIDEON:	fragments of bone.

MARY *tries to move one of the bodies off the platform.* **GIDEON**, *exhausted, is immediately furious.*

GIDEON:	Mary!
MARY:	I'm just –
GIDEON:	Mary, what the hell are you doing?
MARY:	I – listen – I want to eat at the dining room table.
GIDEON:	Well you can't. Put it down. Put the fossil down.
MARY:	I've told you before.
GIDEON:	They're in order, Mary.

She doesn't put it down.

MARY:	No. I –
GIDEON:	Mary –
MARY:	I'm sick of eating in the kitchen.
GIDEON:	I said not to touch it, they're –

MARY:	We want the room back. The children and I need –
GIDEON:	Do not touch, Mary, didn't I say?
MARY:	And I'm just putting them –
GIDEON:	They are in order.
MARY:	Yes, and I'm putting them in exactly the same order on another table.
GIDEON:	But they're in –
MARY:	The children and I –
GIDEON:	They are my –
MARY:	We can't live like this anymore.
GIDEON:	Mary, do not touch. Do not touch.

She picks up another 'fossil'. A stand-off.

> Put it down.
>
> Down.
>
> Down.
>
> Put it down.
>
> Mary?
>
> Put it down.

MARY:	Or what?

He says nothing. She moves it away.

He snaps – begins throwing everything from the stage into the far corner.

GIDEON:	Right. That's what you think isn't it? That I'm a joke. I'm wasting my time. I've wasted my time. Because I'm just a joke to you and my work – my work is a joke and – hours of effort this took, but I'll just do it again, why not? Hours more. Hours and hours and hours but as long as everything is nice and clear for Queen Mary.

He finishes, panting. They look at each other.

Are you happy now?

Beat.

MARY: I'm on your side.

She goes out.

He is alone – except for **OWEN**.

GIDEON: *(To* **MARY**.*)* But then I found it, Mary. Mary?

She doesn't come back. He turns to **OWEN**.

I found it. Proof. Not a jaw, but more teeth.

The scene becomes –

THE GEOLOGICAL SOCIETY OF LONDON

GIDEON: My Lords?

The **SOCIETY** *members stop speaking and turn to look at him.*

SOCIETY 1: Oh my god, look who it is.

Gideon Mantell. Country doctor.

GIDEON: My Lords – I ask you to consider this new proof –

SOCIETY 1: I thought we told you last time?

Now I'm going to ask you politely to fuck off.

They turn away. He speaks to their backs.

GIDEON: My Lords, I ask you to consider these new teeth.
As you know, unlike mammals, reptiles grow new
teeth throughout their lives, replacing the old in a
continuous cycle. These new teeth I've found have
marks on the base – marks from being pushed out of
the gums by the teeth that came behind.

Proof at last – the creature is not a rhino – it has to
have been a reptile.

119

No answer.

My lords?

(To **OWEN**.*)* I had no choice. I had to go to the top.

The **SOCIETY** *is startled by the arrival of* **CUVIER**.

SOCIETY 1: Baron Cuvier!

(To **GIDEON**.*)* You wrote to the Baron?

CUVIER: I have just arrived from Paris.

SOCIETY 1: *(To* **GIDEON**.*)* You had no right to do that.

CUVIER: *Ou est le tooth?*

SOCIETY 1: *(To* **GIDEON**.*)* Who do you think you are? Fucking country doctor.

CUVIER: *Messieurs!* The tooth.

GIDEON *hands it over. He looks at it – the same way* **PARKINSON** *did earlier.*

C'est bon. It is a reptile!

SOCIETY 1: It is?

It is.

Of course! I always said it: Mantell the genius, and his magnificent giant iguana!

What did you call it again?

GIDEON: Iguanodon.

SOCIETY 1: The Iguanodon! Welcome to the Geological Society!

GIDEON: Thank you. Mary –

SOCIETY 1: And welcome to The Royal Society!

GIDEON: Thank you. Mary–

SOCIETY 1: And here's the Wollaston medal.

He kisses **GIDEON** *full on the mouth. It's a shock.*

But Mr Mantell, where are you going?

GIDEON: I've – got to get home.

SOCIETY 1: Of course. Back to the quarries eh?

GIDEON: No, no.

I've got to get back to my practice.

SOCIETY 1: Your practice?

GIDEON: My medical practice.

SOCIETY 1: Gosh. Do you still do that?

GIDEON: …

Yes.

SOCIETY 1: Golly. But where will you find the time?

GIDEON: The time?

SOCIETY 1: To make something of yourself, Mr Mantell.

Have a crack at the history books.

GIDEON: But –

SOCIETY 1: I don't mind telling you, we were all waiting with bated breath to see what you'd dig up next.

I don't know – maybe there's more of them out there. A whole menagerie of ancient monsters. And we rather saw the field as yours –

But of course, we understand.

You've got your patients.

And that comes first.

The seduction is complete.

The scene becomes –

THE MANTELLS' HOME

GIDEON: Mary.

MARY: What?

GIDEON: We're moving to Brighton.

I don't want to be a doctor anymore.

MARY: Brighton?

GIDEON: I've sold the practice.

MARY: You've done *what*?

GIDEON: Yes. I've sold it. And I've sold the house. And I've found us a new one. It's beautiful Mary – oh, it's huge! Five floors, opposite the palace.

MARY: But we don't need five floors.

GIDEON: No no – the first two floors are for the collection. It's going to be a museum. We have the best fossil collection in the country, Mary, and it's just sitting on our dining room table.

MARY: I *know*.

GIDEON: We've got to make something of ourselves Mary! We have a wonderful collection and soon we'll have the finest museum of its kind in the country. I'm going to add to the collection, find more fossils – who knows what's out there – and of course I'll have to buy more, I've already started –

MARY: But we can't afford–

GIDEON: No but we can. Lord Egremont has given me a thousand pounds to start the museum. And once it's open, who knows?

He kisses her violently.

MARY: No, no – our life is here. Our life is here.

GIDEON: Why are you never happy?

Beat.

MARY: Do I have a choice?

The scene becomes –

THE MUSEUM IN BRIGHTON

SOCIETY 1: Mr Mantell, this collection is a monument of original research and talent.

GIDEON: *(To OWEN.)* The museum was a hit.

SOCIETY 1: An assemblage of treasures which required zeal inspired by genius!

GIDEON: Over a thousand people came in the first week.

SOCIETY 1: Mr Mantell – this museum is more perfect than any other in Europe.

You truly are the lion of the season.

They kiss.

GIDEON: If fame and reputation could confer happiness then I could say I was truly happy. But for the first time in my life, I was running out of money. Fast. We'd spent the thousand pounds and there was nothing coming in. The museum was so popular, I thought perhaps I could charge a small entrance fee–

SOCIETY 1: *(Interrupting.)* Ooh, entrance fee?

GIDEON: Sorry?

SOCIETY 1: Did you say entrance fee?

GIDEON: Yes.

SOCIETY 1: Little bit vulgar, don't you think?

GIDEON: No – yes of course – it is vulgar, you're right. Grubby.

SOCIETY 1: Bit of advice, Gideon? Much more gentlemanly not to.

GIDEON: *(To OWEN.)* So we didn't.

	But I still didn't have any money. I knew I needed a patron, someone who could sponsor my work, but of all the gentry who visited the museum, nobody wanted to help.
SOCIETY 1:	*(Leaving.)* Yes sorry old chap. I'd love to but, uh, you know how it is…
GIDEON:	Things were becoming desperate. Every month I travelled to London to cash what little savings I had but they were running out.
	What else could I do? Much as I'd tried to escape it, I was still a doctor. So I set up another practice on the top floor of the house and waited for patients to come.

Silence. After a time, **TWO MEN**.

MAN 1:	Excuse me, is this man a medical doctor?
MAN 2:	Yes.
MAN 1:	Oh, I thought he was a rock doctor.
GIDEON:	But I was a victim of my own success
MAN 1:	I'm not being funny but I don't want a fossil man looking at my, um, my –
GIDEON:	I had become so well-known as a geologist, nobody wanted to come to me for medical treatment. Still, I held out hope. The weeks passed, and I became a prisoner in my own home: waiting for patients, hoping for patronage, surrounded all the time by nothing but bones. All these reptilian bones. Cold blooded.
	I won't embarrass myself, Mr Owen, by giving you details of every absurd scheme I either attempted or considered in those desperate months – suffice to say none of them worked. And in the end, only one option remained.

MARY *is with him. They are alone.*

MARY:	You need to sell the collection.

Gideon?

You need to sell the collection. It's the most valuable thing we have.

Please. You need to sell the collection – we need to move somewhere else, buy another practice. Put all this behind us.

Are you listening?

Am I alone?

GIDEON: I am a member of the Geological Society, Mary, the Royal Society, my friends are gentlemen of science. They will not let this happen to me.

MARY: Those men are not your friends.

GIDEON: They respect me.

MARY: They don't respect you.

GIDEON: They respect me.

MARY: They don't care about you, Gideon. They're just – rich people.
I am your wife. Does that not mean anything?
Gideon.

GIDEON: Of course –
Of course they do. They respect me, Mary. Because I am the best.
Because I discovered the Iguanodon from a tooth, because I have discovered a whole world that nobody else has, because this is the job God made me for.
I can't sell my collection.

Beat.

MARY: I see. I understand. Completely.

She leaves. A moment.

GIDEON: After…

125

After Mary and the children left. I still needed to find a patron.

I decided to swallow my pride, head to London and see if any of the Society would help me.

I boarded a carriage – and I don't know if the weather was bad that day, or the road was uneven – but somehow, the coachman lost control of the horses.

I tried to grab the reins but I was flung to the ground. The wheels caught my head and I was dragged along the road for some distance.

His back becomes twisted again, as we saw it before. We are back in **BUCKLAND**'s *drawing room.*

When I came to, I was paralysed, but as the months passed, sensation has gradually returned.

I can walk, Mr Owen – just – but I am in constant pain. As you know, the collection was sold anyway, at half its value, to pay for my life as an invalid.

I kept only this tooth.

He takes it out.

I tell you all this not so that you will pity me, Mr Owen – but – you're the Great Man now.

I only ask that in your new paper, you will acknowledge my labours.

I support your efforts, I hold no truck with Mr Lamarck and the progressionists. I have only ever worked to illuminate God's creation.

But the Iguanodon has cost me everything. And I wanted you to know.

He holds out the tooth.

OWEN *takes it.*

He watches **GIDEON** *leave.*

The stage is his.

PART FOUR:
OUT OF TIME.

CHORUS: In August 1841, Richard Owen presented his report
on the British Fossil Reptiles to the British Association
for the Advancement of Science in Plymouth.
Eighteen years before Charles Darwin published *On
the Origin of Species*. It was a highly technical talk and it
lasted over 2.5 hours.

OWEN is centre-stage. The CHORUS pass him a card to read from.

OWEN: Thank you.

My Lords, before I present my findings today, I would
like to begin by saying what a privilege and an honour
it has been to undertake this task for such exalted
company.

They pass him a card to read from.

Unfortunately, up to this time, the field has been
dominated by amateurs, mere collectors playing at
science, who – doubtless with good intentions – have
attempted to interpret their fossil finds by seeking
comparison with existing animals.

They pass him a card to read from.

My lords, these amateurs have only opened the
door to progressionist heresies, which would have us
believe that by processes unknown these magnificent
extinct beasts have transformed themselves into
modern reptiles.

They pass him a card to read from.

Gentlemen, I have clarified the ancient world, I have
classified the extinct reptiles and give them their true
place in God's creation.

They pass him a card.

Take the Iguanodon: so-named because its teeth
apparently resemble that of the iguana. I say to
you now, the very name Iguanodon is a scientific
inaccuracy, which has held back the field for a decade.

For my lords, I have split these teeth open.

He dashes the tooth onto the floor.

I have cut them into slices. I have put them under the
microscope and believe me when I say – they share
nothing with any living reptile teeth. The internal
structure is unique.

They pass him a card.

And yet Dr Mantell's foolish act of comparison – well-
intentioned as it may have been – has misled us into
seeing some kinship between the extinct animal and
the living lizard. A dangerous inaccuracy.

They pass him a card.

And I have proof.

A card.

I have spent the money entrusted to me by this society
in travelling the length and breadth of the country.

A card.

I have travelled further and faster than my colleagues
to seek out every fossil reptile specimen there is.

A card.

I have seen specimens that country Doctor Mantell
could never have seen, fossils not discovered until long
after the accident that crippled his spine.

GIDEON *is brought in, held by a member of the chorus.*

I have beaten this man in a race he could never have won.

A card.

I have found the thing that makes these creatures a
class apart.

The fused vertebrae at the base of the spine of
every. Great. Extinct. Reptile. The Hylaeosauros, the
Megalosaurous, and the so-called Iguanodon.

I have seen how this fused spine allowed them to carry
their great bulks on huge, pillar-like legs. Unlike any
other living reptile. To suggest that an iguana is an
iguanodon improved is both absurd and anatomically
inaccurate.

He has a gun.

This isn't progress. There has been no progression.
God created these creatures just as he chose to destroy
them.

OWEN *shoots* **GIDEON**. *He stands upright. The actor is now part of the*
CHORUS.

CHORUS: *(Sung repeatedly under the following.)* Deinos

OWEN: I have recognised the magnificence and singularity of
these creatures, and to protect us from progressionist
error –

I have placed them in a class of their own.

And I have given that class a name:

Deinos from the Greek, meaning great, awe-inspiring –
and unknowable.

I have named it dinosauria.

And in naming them, I have created them.

A card.

I have put a flag with my name on it in bones that are
hundreds of millions of years old.

A card.

129

I have claimed the ancient world for myself, erasing all the work that came before me, erasing all of this man's work.

A card.

When I finish my speech, you applaud my greatness. I have been recognised as the victor.

I have been named the winner.

A card.

I have been awarded Royal patronage – an annual sum from Queen Victoria herself –

A card.

I have found proof in nature of the divinity of man and the rightness of the British Empire, which will last millennia.

A card.

I have been invited to serve on the committee for the Great Exhibition, a celebration of modern technology. I have a part in deciding what the future will look like. I own the future just as I own the ancient world.

A card.

When the Great Exhibition opens, I have the best seats in the house, amid the great men of the age.

Mantell is there too. A hunched figure at the back. We don't speak.

The actor who played **GIDEON** *begins to cross the stage. They walk to the back corner where the pile of bodies is.*

A few weeks later, Mantell dies. Alone. From an opium overdose.

The actor who played **GIDEON** *lies down on the pile of bodies.*

I have his broken spine removed from his body. A curiosity.
A twisted thing. I have it placed it in a museum.

A card.

I have another fifty years to live after today.

A card.

I have time.

A card.

I have enough time to create my greatest work: I build
a cathedral to the natural world, a monument to God's
creation, and I call it the Natural History Museum.

A card.

He reads it. Shakes his head. Throws it away.

Another card.

He reads it. Throws it away. Holds his hand out for another.

They hand it to him.

This time, when he looks up, the **CHORUS**, *who have stopped singing by now, have
a gun pointed at him.*

OWEN *begins to read.*

I – have enough time –

to see my museum become a monument to my last and
greatest rival, Charles Darwin.

A card.

I have enough time to destroy my career.

A card.

I throw myself between Darwin and the tide of
progress. Finally, I am the one swept away.

A card.

I have enough time to see the wife and child I love die
before me.

A card.

I have a room at the top of a house. My only
grandchild lives downstairs.
He is frightened of me.

A card.

I have become a monster at the top of the stairs.
A relic.

A card.

He reads it.

Eventually, he reads it aloud.

And then I die.

OWEN *walks over to the pile of bodies and lies down beside* **GIDEON**.

They shoot him.

The two actors who are left stand on the platform. The actor who played **GRANT**
picks up the tooth. They hand it to the actor who played **MARY**.

They look at it.

They look at each other.

They look up to the light.

It goes out.

End.

CPSIA information can be obtained
at www.ICGtesting.com
Printed in the USA
LVHW040320130821
695224LV00023B/2941

9 781913 630102